# FOCUS IN ON QUALITY

To get rid of blurring, shadows, tilting, boring composition, disharmonious backgrounds, and the like . . .

To use different types of lighting and color properly . . .

To choose the right lenses, filters, and other attachments . . .

To find out how modern technology can protect you from much trouble and wasted film . . .

To understand the types, features, and techniques of flash use . . .

To learn all the common problems of picture taking and master the guidelines to good composition . . .

## The Good Guide for Bad Photographers

ABOUT THE AUTHORS:

TOM GRIMM AND MICHELE GRIMM are free-lance photographers and writers based in Laguna Beach, California. Their work has taken them to over a hundred countries and has appeared in numerous leading magazines and newspapers. The couple has illustrated and/or written twelve other adult and children's books. Two other very popular books by Tom Grimm, *The Basic Book of Photography* and *The Basic Darkroom Book,* also are available in Plume editions.

# The Good Guide for Bad Photographers

## How to Avoid Mistakes and Take Better Pictures

### BY TOM GRIMM AND MICHELE GRIMM

Photographs by Tom Grimm and Michele Grimm
(and others who wish to remain anonymous)

Drawings by Ezelda Garcia

A PLUME BOOK
**NEW AMERICAN LIBRARY**
TIMES MIRROR
NEW YORK AND SCARBOROUGH, ONTARIO

NAL BOOKS ARE AVAILABLE AT QUANTITY DISCOUNTS WHEN
USED TO PROMOTE PRODUCTS OR SERVICES. FOR INFORMA-
TION, PLEASE WRITE TO PREMIUM MARKETING DIVISION, THE
NEW AMERICAN LIBRARY, INC., 1633 BROADWAY, NEW YORK,
NEW YORK 10019.

PLUME TRADEMARK REG. U.S. PAT. OFF. AND FOREIGN COUNTRIES
REGISTERED TRADEMARK—MARCA REGISTRADA
HECHO EN WESTFORD, MASS., U.S.A.

SIGNET, SIGNET CLASSICS, MENTOR, PLUME, MERIDIAN and NAL BOOKS
are published in the United States by The New American Library,
Inc., 1633 Broadway, New York, New York 10019; in Canada by The
New American Library of Canada Limited, 81 Mack Avenue, Scarborough,
Ontario M1L 1M8

**Library of Congress Cataloging in Publication Data**

Grimm, Tom.
The good guide for bad photographers.

Includes index.
1. Photography—Handbooks, manuals, etc.
I. Grimm, Michele. II. Title.
TR146.G6963        770        82-2139
ISBN 0-452-25327-6        AACR2

First Printing, June, 1982

1  2  3  4  5  6  7  8  9
PRINTED IN THE UNITED STATES OF AMERICA

*For Elsie and Al Poska*

## ACKNOWLEDGMENTS

We want to acknowledge the photographers who let us use their lousy pictures for some of the examples in this book, but we agreed to protect their identities and cannot give their names. Instead, we're giving each one a copy of *The Good Guide for Bad Photographers!*

—Michele and Tom Grimm

# Contents

# The
# Good Guide
# for Bad
# Photographers

# Are You a Bad Photographer?

To see if you need this book to help you take better pictures, look at the following photos and answer the questions.

*Do you ever hear complaints about your family group shots?*

*Do people get seasick looking at your pictures?*

*Do your flash pictures ever leave your subjects in the dark?*

*Do people you photo-
graph in the sun squint
until they are almost un-
recognizable?*

*Does your favorite subject seem to be your finger or camera strap?*

*Do you think your auto-exposure camera always exposes for the subject you want?*

*Do you ever end up with the wrong subject in your picture?*

*Do the parties you shoot sometimes look like unhappy occasions?*

*Do your subjects often have objects growing out of their heads?*

*Do you just hope and pray your camera will get everything in focus?*

*Do your subjects ever move faster than you do?*

Do these pictures look like the ones you take? If your answer is yes, then this is the book that will really help you improve your photography.

In the first part of this illustrated guide we'll show you how to get better pictures by concentrating on composition. You'll see that following a few simple rules will make quite a difference in the outcome of your images.

Next, we'll point out the technical problems that frequently cause poor pictures, and show you how to avoid them. Being confident with your camera doesn't take an engineer's degree, but you must be on the lookout for some pitfalls.

In the third part of the book we'll give you all kinds of ideas about the best ways to photograph people and events. A good picture takes a little forethought, whether you're shooting your baby's portrait, a family reunion, holiday parties, or your vacation trip.

Finally, since you'll soon be taking lots of great photos, we'll offer some ideas about how you can show them off. You'll learn the ideal ways to make an album, mount and frame pictures, project slides, and make photo greeting cards.

By the way, this book is for everyone, regardless of the kind or brand of camera you use. Our tips cover all types of equipment, including pocket and Instamatic cameras, 35mm reflex and rangefinder models, and Polaroid and Kodak instant cameras.

If you're anxious to become a better photographer, just turn the page.

# Part I

## Composing Yourself and Better Pictures

Remember the day your daughter was dressed up in a hula costume and you got out the camera to take a great photograph of her for the family album. Now, a week or so later, the prints or slides are back from the processor and you're taking your first peek.

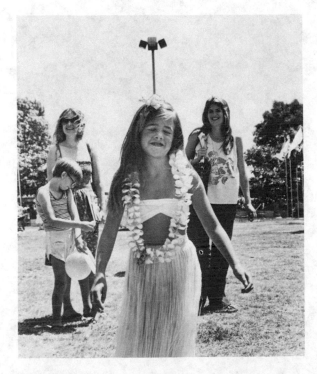

*"Hmmmm . . . it looks like I cut off Mary's legs . . . too bad her eyes are closed . . . and I never noticed that pole coming out of her head, or those people in the background."*

Instead of jumping with joy over your "great" shot, you're downright disappointed. The picture didn't turn out the way you imagined it would. Well, there's no reason to put down your camera and take up tennis. You *can* take better pictures.

Today's cameras are more automatic and easier to use than earlier models, so the big hurdle on the road to better photography is not the complexity of the equipment. It's the careful arrangement of all the elements in your picture. In other words, *composition*. Good pictures are those that are well composed by the photographer, not just moments of chance.

# 1.
# Composition Is the Key

Worthwhile pictures rarely just happen. Usually something catches your eye and makes you decide it would be a good picture, but what you're seeing is real and three-dimensional. When it becomes a photograph, the image is frozen and flat, an unchanging two-dimensional representation in color or black-and-white.

How do you put life and impact in a picture—something to make it memorable? The simple answer is to concentrate on composition. Even if all your shots aren't award winners, at least you'll be proud to keep them instead of tempted to throw the pictures away. Friends who see your photos will like them better, too—and probably be a bit jealous of your newly found talent as a photographer. (If you're tired of looking at *their* bad pictures, give them a copy of this book.)

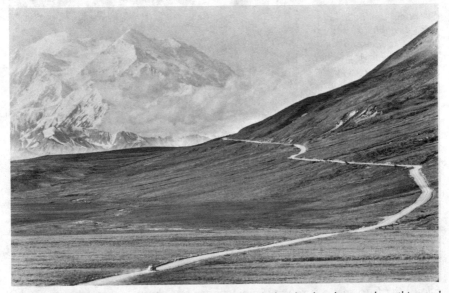

*One technique for improving composition is to include a leading line, such as this road that goes toward Alaska's Mt. McKinley and helps direct viewers to the picture's main subject.*

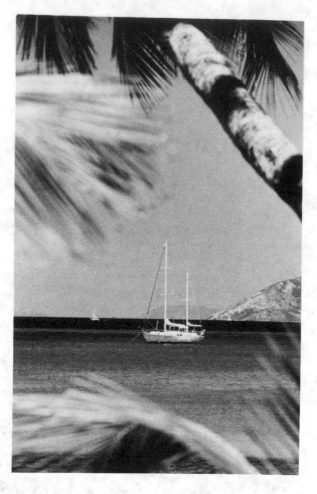

*Shooting the main subject through a natural frame, like these palms in the Caribbean, is another technique to improve the composition of a photo.*

Why is it so important to arrange or compose a photograph? First of all, every good picture has a purpose, a theme, or a point of view that the photographer wants to share. It tells a story. As the old, and usually misquoted, Chinese proverb says: A picture is worth more than 10,000 words.

Of course there weren't Instamatics back when the proverb was written, but painters have known for centuries that the use and arrangement of lines, shapes, textures, and colors contribute significantly to any picture's message. Likewise, a photographer must recognize and decide how to use the elements of composition that will convey his story creatively.

One thing, for instance, is giving better balance to a picture by following the *rule of thirds* to make sure your subjects are not always centered in the camera's viewfinder. Or you can add interest by *framing* your subject with an object in the foreground. Another idea is to include *leading lines* in the picture to

direct attention toward your main subject.

Techniques for improving composition will eventually become second nature to you. For example, a so-so subject often makes an impressive picture if you simply change the camera's position. You move to the left or to the right, get closer or back away, kneel down or climb to a higher vantage point. Even just turning your camera from the usual horizontal position to a vertical format can mean a big improvement in a photo. Another way to give your pictures more impact is to change the camera's shutter speed to show the action of your subjects—using a faster shutter speed to stop the action, or using a slower shutter speed to show it as a blur.

Later in this section are a number of guidelines and techniques for better composition, with bad and good illustrations so you'll see how easily a picture can be improved. To begin, however, let's be negative (which is certainly appropriate for a book about photography).

# 2.

# Common Problems to Avoid

## Blurred Pictures

Are you one of the countless people who just take snapshots—those impulse pictures for the memory album? Not only do most snapshot shooters show little concern for composition, but they trip the shutter carelessly too. In fact, that's the number one problem with poor snapshots—they're blurred.

The most common reason is that the photographer jabs at the shutter re-

*When a picture is blurred like this one, camera movement is the cause.*

*If you hold your camera steady and squeeze the shutter button instead of jabbing it, the same photo will look like this one.*

lease. This moves the camera the moment the picture is being taken, and the image is blurred.

You can improve your pictures immediately by remembering to *squeeze* the shutter button. When your camera is empty, practice squeezing the shutter release in front of a mirror to make sure you're not moving the camera.

Always use the tip of your finger to press the shutter button. If you press with the flat bottom of your finger, it may touch more of the camera than just the shutter release, which will cause the camera to move and blur the picture.

Besides being careful to squeeze instead of jabbing the shutter button, be sure to have a good grip on your camera. Hold it securely with both hands. The camera also will be steadier if you keep both arms tucked in and braced at your sides, not up in the air like a couple of wings. Make sure your feet are planted firmly and slightly apart, too. Think of your body serving as a tripod whose purpose is to hold the camera steady.

*Holding a camera steady is difficult when your arms are extended like a pair of wings. Also, someone might bump your arms and cause the camera to move.*

Unless your camera takes pictures with only a square format, like the older Instamatics, you should learn to hold it steady in a vertical position as well as in the usual horizontal position. Lazy photographers hold the camera horizontally because it's more comfortable, but composition often can be improved simply by turning the camera vertically. So practice holding your camera in a vertical position. Keep your arms tucked in, and be careful the camera case or strap doesn't fall in front of the lens.

*The best way to hold a camera steady is by tucking your arms in and resting them against your body. Be sure to practice holding the camera steady in a vertical position as well as the more common horizontal position.*

Sometimes it's easier to hold a camera steady if you exhale just before you're ready to press the shutter release.

Another way to avoid blurred pictures because of careless camera movement is to shoot with a faster shutter speed. For casual shooting, 1/125 second is a good choice. An even faster shutter speed may be needed when you use a telephoto lens, because even the slightest camera movement can cause considerable blurring.

Some cameras with automatic exposure control adjust the shutter speed according to the lens opening you've set; before shooting, check that shutter speed to see if you need to reset the lens opening so the shutter will automatically be adjusted to a faster speed in order to avoid the problem of blurring.

Of course, some people are steadier than others and can successfully hold their cameras at slow shutter speeds. If you're in doubt (or have been partying), brace yourself against something solid like a room wall or a tree trunk, or use a tripod to keep the camera from moving when you press the shutter release.

Not all blurred pictures are caused by camera movement. If the image is uniformly fuzzy, you forgot to focus properly. (When camera movement is the fault, the image is more distinct and appears to blur to one direction.) If only

*Camera movement did not cause the slightly fuzzy hand and hair in this close-up candid portrait; the photographer is sharply focused on the most important aspect of a person's face, the eyes.*

part of your picture is blurred and the rest is sharp, your shutter speed was too slow to stop the action of the moving subject. (This does not necessarily make a picture bad, as you'll soon read.)

To repeat, step one on the road to better photography is to avoid blurred pictures by holding your camera steady and squeezing the shutter release!

## Crazy Cropping

How many times have you gotten pictures back from the processor and discovered some of the subject has been cut off? You remember six people posed for the family group shot, but only five appear in the photo. In another print, half of the dog is missing. Well, the processor isn't responsible for such crazy cropping—you've got to pay more attention when you aim the camera.

Everything you want in your picture must appear in the camera's viewfinder. And you should see everything at one time without moving your head around

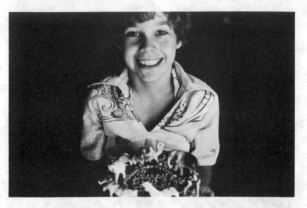

*Only what appears in the camera's viewfinder will be in your picture.*

*This photo of a boy and his birthday cake was improved by turning the camera for a vertical format instead of a horizontal one.*

while looking through the viewfinder. Get your viewing eye as close as possible to the viewfinder, and shut the other eye. This helps you see your subjects in the viewfinder more distinctly and makes composition easier. Some camera viewfinders can be equipped with a rubber eye cup to make viewing better, especially if you wear eyeglasses. It protects your glasses from possible scratches, too. Carefully study what's in the viewfinder, because that's what will be in the picture.

## Distracting Background

Usually you're concentrating on the main subject when you take a picture and don't notice what's in the background until you see the prints or slides. Then it's too late—the background is distracting and draws attention away from the main subject. You can avoid this all too common error by simply avoiding a busy background.

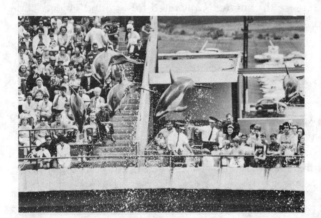

*A distracting background makes it difficult to see the five leaping dolphins in this picture.*

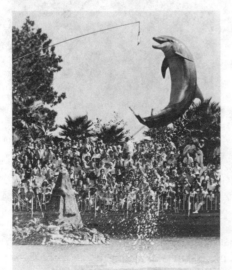

*Shooting from a lower camera angle made it easy to isolate this performing dolphin from the busy background.*

Change your camera angle or your subject's position. Get low and shoot your subject against the sky—it's plain enough to keep attention on your main

subject. Or if the ground is attractive and simple, use it as the background by photographing your subject from a high angle.

By all means, avoid backgrounds where trees or poles seem to be growing out of people's heads.

One way to eliminate a disturbing background is to throw it out of focus. A concept called depth of field allows you to do this by using a wider lens opening (see page 63).

Always remember to look beyond your subject in the viewfinder to study the background before you release the shutter. Unwanted foreground objects can upset the picture's composition, too, so watch out for them as well.

## Tilted Horizon

If things seem a bit cockeyed in your prints or slides, you probably didn't notice the horizon wasn't level when you took the picture. The horizon must appear straight or it will be very distracting, especially in scenic shots. Even when your subject is posing for a portrait outdoors and the horizon is very distant, check just before you squeeze the shutter release to make sure the horizon doesn't look tilted in the viewfinder.

This picture is upsetting because the photographer was concentrating on the water skier skimming along Lake Powell and didn't notice the horizon was tilted in the viewfinder.

Before you press the shutter, always check the horizon to make sure it will appear level in your picture.

## Upsetting Shadows

Your eyes adjust to extremes in contrast, such as bright sunny areas and dark shadows, but film cannot. Study the scene in your viewfinder to see if shadows are predominant and will be distracting. If so, change the position of your camera or the subject. You also can use flash or reflectors to "fill in" shadows by adding light to the dark areas (see page 43).

Remember to be aware of your own shadow, unless you want to include yourself in the picture too. And watch out when you're taking shots of people

under trees—sun shining through the leaves may make unflattering spots on their faces.

*Your eyes easily adjust to sun and shadows but film does not, so look out for shadows from tree branches or leaves that may be bothersome in your pictures.*

Also remember that your camera's exposure meter may be fooled by dark shadows, causing the bright areas of your subject to be overexposed and look washed out. Avoid this by getting close to the bright areas of your subject when making an exposure reading.

## Centered Subject

Do you think about the location of your subject in the viewfinder before you press the shutter release? You should. Unfortunately, too many times the subject is centered right in the middle of the picture. Centered subjects usually are more static and less interesting than those positioned according to the "rule of thirds."

This basic concept of composition is used almost unconsciously by good photographers. You mentally divide the scene in your viewfinder in thirds, both horizontally and vertically. Then you place your main subject along one of the four imaginary lines, or where two of the lines intersect. Usually the subject should face or move toward the center of the picture, not away from it.

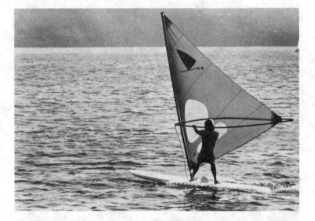

*The photographer composed this picture according to the "rule of thirds," so that the windsurfer is moving toward the center of the picture.*

With scenic views, do not let the horizon divide the picture in half. Move the horizon to the upper or lower one-third of your viewfinder. In a scene where the sky is unimportant, it should be in the upper third and the main subjects should fill the lower two-thirds of the picture area. On the other hand, if the sky is the most interesting part of the picture, it should occupy the upper two-thirds of the viewfinder, and the area below the horizon should be kept in the lower third.

For portraits, with the camera turned vertically, if you center the person's head in the viewfinder there will be wasted space at the top. Instead, locate the

*Applying the "rule of thirds," this informal portrait subject fills up the picture area so the most important facial aspect, his eyes, are located along the imaginary upper one-third line.*

person's eyes along the imaginary upper one-third line and the picture will have much more appeal. Remember, as a general rule, your picture's center of interest should *not* be in the center of the picture.

## Lack of Action

Look at your pictures. Are they stilted and lifeless? Just because you're taking "still" pictures doesn't mean your subjects have to be still when you photograph them. Informal pictures of people always are better if your subjects are doing something. For that reason, candid shots usually are superior to posed pictures because they are lifelike and reveal natural expressions and action.

Even if you have to organize your subjects, as for a group picture, don't let them become stilted. Make sure they're relaxed. Have your camera ready and the exposure reading made so your subjects don't get tired waiting for you. Be set to shoot when they flash the expressions you want. Don't say *"Hold it!"*— the result often looks unnatural. With portraits of babies, children, or pets, give them something to keep them occupied and their attention off you. A toy or a snack treat works well.

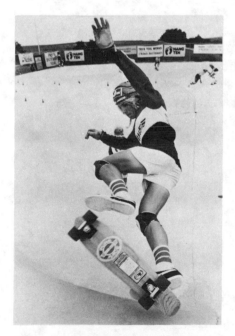

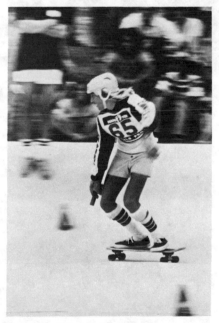

*A fast shutter speed stops the action of this professional skateboarder who loses his board during trick competition.*

*Panning with the camera helps show the speed of another skateboarder in a relay race.*

There are several ways to show action in your pictures, and varying the shutter speed is the most common technique. You use a fast shutter speed to stop or freeze the action at a dramatic moment, or you use a slow shutter speed so the moving subject blurs and puts a feeling of action in your picture. You also can use techniques called *panning* and *zooming.* The various ways to show action in your still pictures are discussed in detail later in this section. Read on.

# 3.

# Guidelines to Good Composition

Now let's be positive and offer some guidelines to good composition. And remember that although some people are said to have been born with a "photographic eye," learning how to compose effective photographs is usually just a matter of practice.

## *Be Sure to Have a Center of Interest*

Do you suppose people who look at your photos wonder what you want them to see? Every picture should have a main subject or center of interest. And it should be obvious, not something you have to point out on the print or slide. When you're composing a picture, be sure that other objects in the scene do not compete with what you intend to be the main subject.

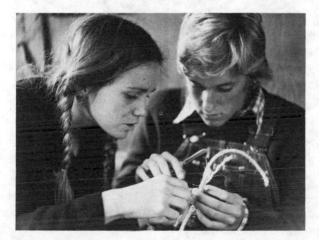

*The sharply focused rope is the center of interest in this picture of Sea Scouts who are learning how to splice.*

Among the successful ways to concentrate attention on your center of interest are to fill up the film frame, use leading lines, frame the subject, and focus for effect.

## Fill Up the Film Frame

For good composition, get close with your camera to fill up the frame with your subject. You should see in your viewfinder only what you want in the finished picture. This is especially important when shooting slides, because everything

*The subject of this photo is supposed to be the young skier, but the photographer was too far away.*

*The picture is greatly improved when the photographer got closer and filled up the film frame with the happy girl.*

included in your camera's viewfinder will be projected on the screen. Of course, black-and-white and color negative film can be cropped during the enlarging process, but most often the full film frame is printed by automatic photo processing machines—so it's always better to crop in the camera before you take the picture. Just move closer to get rid of everything that's not necessary or will be distracting to your composition. If it's impossible to move physically closer or you don't want to disturb your subjects, use a telephoto lens to make a larger image of your main subject on the film.

## Use Leading Lines

Attention can be directed to the center of interest of your picture by using leading lines. In scenic views, for instance, a road or fence or river can be included in the picture to lead to your main subject. Even shadows can serve this purpose. Be sure that the lines guide attention toward the center of inter-

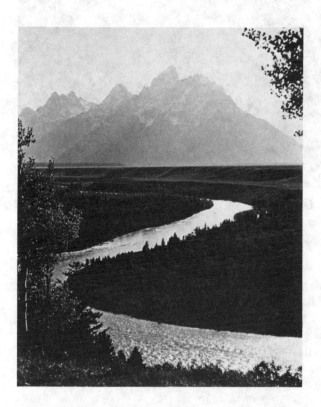

*The curling Snake River leads toward this picture's center of interest, the Grand Teton mountains.*

est, not away from it. Always study a subject area to see if there are leading lines you can incorporate when composing a picture.

## Frame the Subject

Another way to direct attention to the main subject is to frame it with something in the foreground. The frame can surround the subject or just border the top or one side. You find all kinds of frames if you look around at different levels and angles. Natural arches, fences, doorways, and windows are some examples. A tree or overhanging branch is very common and effective in framing a scenic shot. Including such a frame is also a good way to hide an unin-

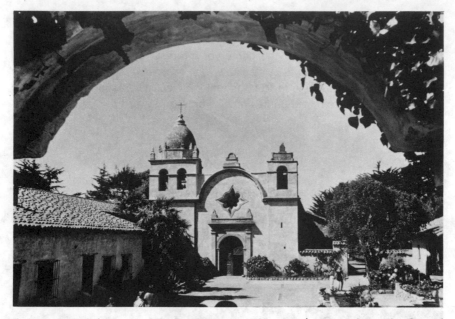

*A doorway arch frames and directs attention to this photo's main subject, the Carmel mission church in California.*

teresting sky. By the way, ecologists and most other people do not like photographers who trim flowers or tree branches to improve the frame. Change your camera angle, not the natural frame.

Because frames are in the foreground, they give a feeling of depth to the picture. In many instances the frames are kept in focus, because a fuzzy foreground can be distracting. Other times you can isolate and emphasize the center of interest by putting the frame out of focus.

## Focus for Effect

Focusing for the best effect is another way to direct attention to the center of interest in your picture. You may be one of the countless photographers who just focuses on the main subject and shoots. But what you must do is study the entire subject area you see in the viewfinder and decide what should and should not be in focus.

For instance, for a scenic view you may decide that you want everything in the picture to be in focus. On the other hand, for an informal outdoor portrait of a person, you probably want the background to be out of focus so your main subject will stand out in sharp detail.

There are several techniques for controlling focus, and these are discussed in detail beginning on page 63.

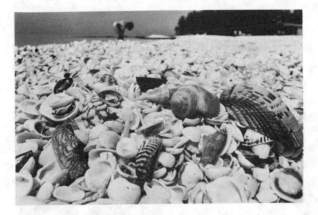

*The background was purposely put out of focus so attention would be directed to the variety of seashells displayed in the foreground on Florida's Sanibel Island beach.*

   *Depth of field* is a term you'll come across frequently in regard to how much of the picture area is in focus. Great or extreme depth of field means most (if not all) of the picture area will be in sharp focus, while limited or shallow depth of field means only a small portion of the picture will be in sharp focus.

   As you become familiar with depth of field, you'll learn how to control it and focus for effect. For instance, the smaller the lens opening you use, the greater the depth of field will be (which means more of the subject area will be in focus). Also, wide-angle lenses characteristically offer greater depth of field than telephoto lenses. Another thing: When you focus the lens on a subject,

*A small lens opening was used to achieve great depth of field so that everything in this picture would be in sharp focus.*

the greater the distance that subject is from the camera, the greater the depth of field will be.

## Change the Camera Angle

Many times the easiest and best way to improve the composition of a picture is simply to change your camera angle. Look at your subject from different positions to find the camera angle that gives the most impact.

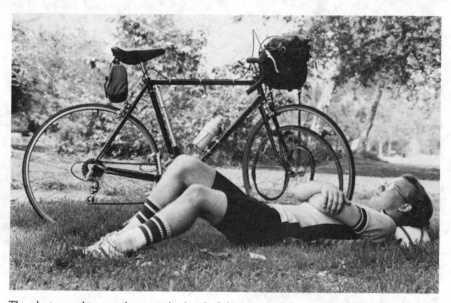

*The photographer got down to the level of this resting biker to give more intimacy and impact to the photo.*

Remember that the height of a photographer's eye is not always the best level for the camera. Kneel down, or stand on your tiptoes. Get even lower by placing the camera on the floor or ground. Or raise your camera by climbing a ladder or a tree, or holding it overhead on a tripod and using the camera's self-timer to trip the shutter.

Shooting up from a low angle makes the subject look imposing and gives it a feeling of strength or power. Shooting down from a high angle tends to diminish the subject and make it appear weak or submissive. For these reasons, try taking pictures of babies, children, animals, and small flowers and plants at their own level.

Changing your angle will alter the lighting on the subject as seen by the camera. Walk around to see if your subject looks better with the light falling on it from the front, side, or back. In bad weather, you can eliminate overcast and

*A slightly higher camera angle was chosen to photograph this couple in order to eliminate a distracting background.*

gray skies by shooting subjects from a high angle. Always remember that the angle of your camera is very important in composition and often can mean the difference between a good or bad picture.

## Vary the Picture Format

Good composition usually calls for wide subjects to be shot horizontally, tall subjects vertically. You can do this with all cameras except those with a square

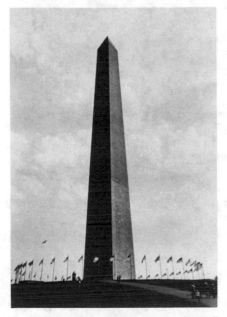

*A vertical format usually is best for tall subjects like the Washington Monument.*

*Aiming the camera so a tall subject is photographed diagonally often makes an eye-catching picture.*

format, like Instamatics that use 126-size film or Polaroid SX-70 instant cameras. If you have a camera that takes rectangular pictures, be sure to vary the format; don't shoot everything horizontally just because that's the easiest way to hold the camera.

For an interesting effect, occasionally shoot tall objects, such as church steeples or flagpoles, on the diagonal. Turning the camera for a vertical format, compose such subjects at an angle that runs from a top corner to the opposite bottom corner of your viewfinder.

## Switch Lenses

If your camera has interchangeable lenses, switching from one lens to another can have a considerable effect on the composition and impact of a picture. The basic types of lenses are normal, wide-angle, and telephoto. A normal lens depicts subjects in much the same proportion and perspective as you see them with your own eyes. A wide-angle lens covers a greater area and subjects look proportionately smaller in the picture, while a telephoto takes in a smaller area and subjects appear larger in the picture.

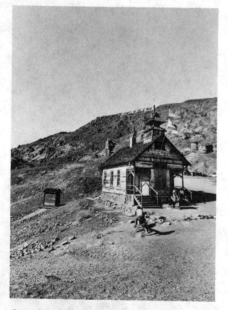 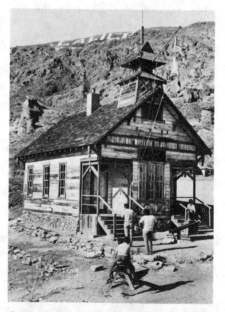

*A wide-angle lens, like the 35mm lens used to photograph this old schoolhouse at California's Calico Ghost Town, covers a greater area than a normal lens and makes subjects appear smaller.*

*On the other hand, a telephoto lens, like 105mm used for this photo, covers a smaller area and makes subjects look larger.*

As for perspective, with a wide-angle lens the background seems farther away from objects in the foreground than it does to the eye. On the other hand, a telephoto lens compresses the distance between foreground and background and makes them appear closer together.

Something else to consider is that wide-angle lenses have greater depth of field, which means it's easier to get more of the entire subject area in focus than when you use a telephoto lens. Conversely, it's easier with a telephoto lens to put the foreground and background out of focus in order to make your main subject stand out.

You'll also discover that wide-angle lenses cause considerable distortion of subjects that are close to the lens, which makes them a poor choice for portraits. Also, if you tilt a camera with a wide-angle lens up or down, vertical lines bend inward at the top or bottom of a picture. The result can be bothersome, as with buildings, or dramatic, as in a forest of trees.

A detailed discussion of lenses and ways to use them most effectively begins on page 80. Be sure to read it so you'll know how switching to a different lens will affect the composition of your picture.

## Vary the Shutter Speed

Two things control the exposure of a photograph—the lens opening and the shutter speed. But shutter speed also plays a great role in the impact of your picture, because you can vary it to show action. You shoot at a fast shutter speed to stop the action, or at a slow speed to let the action blur in your picture.

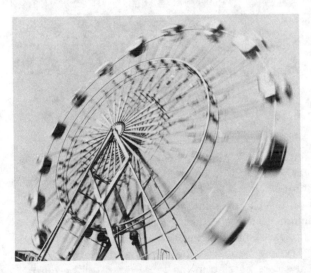

*Using a slow shutter speed will show action in pictures of moving subjects, such as this Ferris wheel.*

Shutter speeds on some cameras, especially 35mm models, often range from 1 second to 1/1000 second. Many photographers use 1/125 second for their "basic" shutter speed, switching to slower speeds like 1/60, 1/30, and 1/15 second when they want the action to blur, and faster shutter speeds like 1/250, 1/500, and 1/1000 second when they want to stop the action.

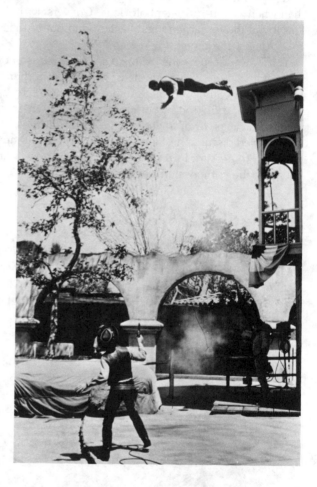

A "wounded" stuntman at Hollywood's Universal Studios is frozen in mid-air by a fast shutter that stops the action.

Study your subject to see what difference a slow or fast shutter speed will make in a picture. For instance, flowers or leaves blowing in the breeze should make an eye-catching picture when they're blurred in motion by a slow shutter speed. The same is true for children riding a merry-go-round, or a grandfather clock with its pendulum swinging. At fast shutter speeds, those objects would be motionless and appear rather ordinary. If you want to show the fans watching a car race, focus on the people in the stands and shoot at a slow enough shutter speed so the cars passing in the foreground will be blurred.

That way your main subject, the spectators, will be emphasized; the blurred racecars help set the scene but will not distract from the people in the stands.

Of course, *stop-action* is very common. Its purpose is to freeze the subject so it can be seen clearly. But stop-action is effective only when people who see the photo realize the subject was moving when the picture was made. A diver doing a backflip into a swimming pool and a pole vaulter frozen in midair are two examples. You must be sure, however, to include a point of reference so people know what the subject is and what is happening. The diver's picture needs a diving board or swimming pool for a reference, or the diver is simply a person in swimming trunks captured in the sky. With a pole vaulter, you should include his pole or the crossbar he is vaulting, or he'll appear only as a man in a track suit suspended in midair.

The correct shutter speed to use to stop the action depends on three interrelated factors: how fast the subject is moving, how far the subject is from the camera, and the direction the subject is moving in relation to the direction of the camera.

First consider the speed of the subject you want to stop. Obviously a speeding racecar is going faster than a running boy.

Then consider the distance the subject is from the camera—the shutter speed must be faster for a subject that's close to you. As an example, a train passing near you will cross your viewfinder faster than a train in the distance that's going the same speed.

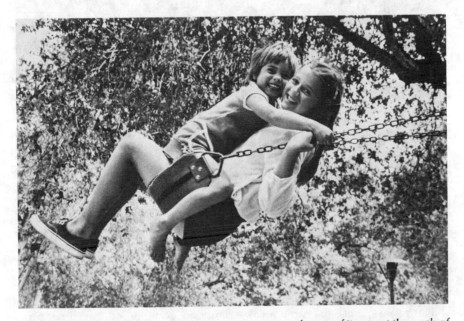

*The photographer shot the moment the swing came to the top of its arc, at the peak of action, to make a stop-action picture of these smiling sisters playing in a park.*

Finally, consider the subject's direction in relation to the direction the camera is pointed. A subject moving across the viewfinder is more difficult to stop than one moving directly toward or away from it. For example, driving along a highway, an oncoming car or scenic view you see through the windshield appears to be moving slower than when you look through your side window and see the car or vista whiz past. So remember, subjects moving at a right angle to the direction the camera lens is pointed require a faster shutter speed than those traveling at other angles.

One way to stop action is to trip your shutter at the *peak of action.* Make your exposure the instant the action is suspended, as when a child and a swing pause in the air to reverse their direction, or when basketball players are at the highest point of their jump. Stopping action at its peak is possible with a slower-than-normal shutter speed, but your timing must be perfect.

Action also can be stopped by *panning* with the subject. This is one of the most effective ways of portraying the feeling of motion in your photographs. It takes practice, too.

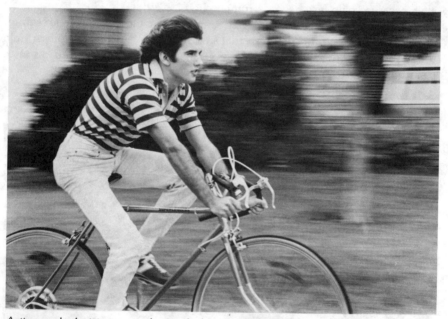

*Action-packed pictures can be made by panning, which means tripping the shutter while following the moving subject in your viewfinder.*

To pan, you follow the moving subject with your camera, carefully keeping it in the viewfinder. When you decide the moment is right, you squeeze the shutter release. Since the camera is keeping pace with the moving subject, the subject will be sharp and the background blurred. The blurring gives the feeling

of speed. However, motion effects vary with the shutter speed you use. Slower-than-normal shutter speeds usually give a very action-packed effect.

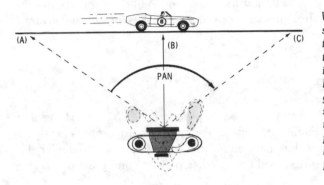

*When panning with a subject, be sure to follow through. To portray motion effectively by capturing the subject against a blurred background, begin by panning with the subject at point A, press the shutter release at point B, and continue following the subject until point C.*

To perfect your panning, prefocus on the spot where you plan to photograph the subject. Stand firmly and pivot your body at the waist. Keep your camera level, or the subject and blurred background will be tilted and distracting. Most important, follow through with your panning motion even after you release the shutter. If you don't get in the habit of following the action after shooting, unconsciously you'll stop panning an instant before tripping the shutter and the effect of panning will be lost. Remember that you can pan vertically as well as horizontally.

Another way to stop action is with electronic flash. Since its quick burst of light lasts only 1/1000 second (and often less), the subject's movement will be frozen. Use electronic flash indoors or outdoors for stop-action shots when the natural or artificial light is not sufficient for the use of fast shutter speeds. Electronic flash is ideal for babies because it will stop their quick expressions and movements. More information about flash begins on page 100.

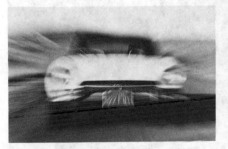

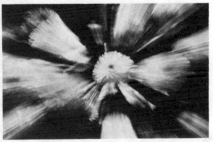

*Static subjects, like this parked car, can be depicted with motion by zooming, which means changing the zoom lens focal length while the shutter is open.*

*Zooming makes an eye-catching photo of these marigold flowers. The camera is held steady on a tripod while the zoom lens is adjusted during the exposure.*

Adjusting a zoom lens (see page 88) during the exposure also gives a feeling of motion, even when your subject is not moving. This is called *zooming*. The camera should be on a tripod, and a slow shutter speed is necessary so you have time to zoom in or out during the exposure. Adjusting the zoom lens causes streaks to radiate from the subject and often makes impressive pictures. Try it.

## Use Good Timing

Timing is important if you want to be a better photographer. You must shoot at the moment of greatest interest or impact. Too many photographers press the shutter release right after they have found the subject in the viewfinder, focused, and set the exposure. Good timing takes patience and practice.

*Good timing caught this juggler in action, with one ball in midair, one caught, and the other being tossed.*

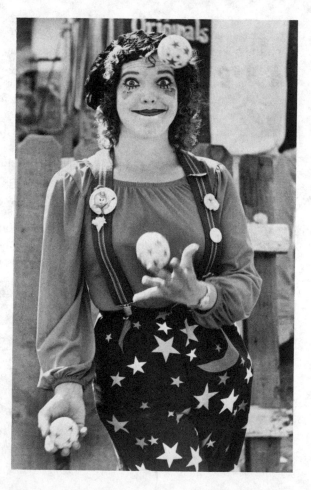

Consider what will be the best moment to shoot and wait for it. Children eating ice cream cones eventually get the ice cream on their faces or clothes, and sometimes even drop the cones. People having a discussion often gesture with their hands. Fishermen usually show excitement when they catch something. Waves splash higher on rocks with incoming tides. If you study your subject and anticipate its action, you'll take more appealing pictures.

For instance, you spot a bird sitting on the top of a nearby tree and it seems like a nice picture. Do you aim, focus, shoot, and then go away? Or do you wait until the moment the bird extends his wings and begins to lift off his perch—and take a much more dramatic picture?

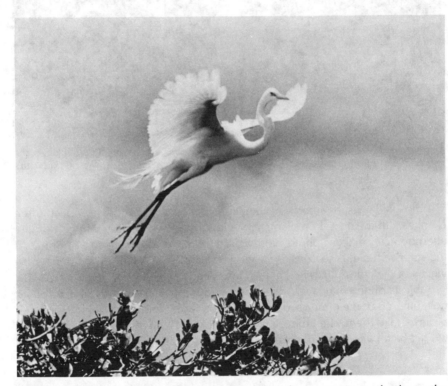

*An egret leaving its perch in a mangrove makes a dramatic picture, thanks to the photographer's patience and good timing.*

Shooting a second too early, or too late, can make the difference between an ordinary and an unusual picture. A golfer blasting out of a sand trap is more exciting than one just about to tee off. A child blowing out birthday candles is much more interesting than one just looking at the cake. A horse galloping can be much more dramatic than one grazing. The point is to study your subjects and figure the best moment to photograph them.

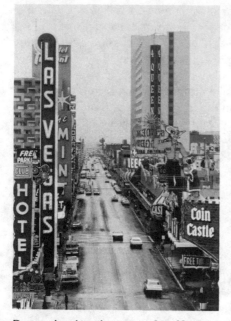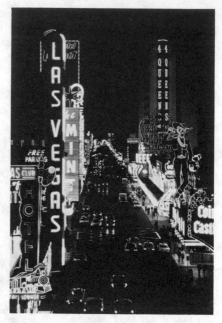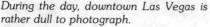

During the day, downtown Las Vegas is rather dull to photograph.

But it comes alive at night, which is the best time to take pictures of that city's bright lights.

Time of day is another consideration, because a picture's impact often changes with the light. For example, the long shadows of early morning or late afternoon can make a photo more effective than if it was taken at noon with the sun overhead. Also consider whether a night shot might be more interesting, as of the colorful casino lights in Las Vegas.

Subjects often change with the time of day, too. For pictures of active kids, wait until after their meals or naps. If you want unhappy children in your pictures, take them when they're tired or hungry. Remember that your pictures will get better when you concentrate on the right time to trip the shutter.

## Consider Color

Most people use color film these days, but they don't always think about the colors that will be in their pictures. You should, because color contributes to the mood of your photos. Cool colors, like blue, can be soothing, while bright colors, like reds and oranges, are quite arousing.

The exposure you use can make a difference too, especially with color slide films. Slightly underexposing color slide films makes colors richer and the mood more intense, while a little overexposing can make colors more pastel and the mood much gayer.

Also, by including subjects of bright color, you can add impact to a dull scene. Separation of subjects from the background also can be accomplished if they are of different colors or at least varying shades of similar colors.

Another thing to consider is that different light sources can make colors look different on film from what we see with our eyes. As an example, fluorescent lights give colors a greenish cast in pictures, unless filters are used over the camera lens. And when pictures are taken of people at sunset, their skin photographs with an unnatural orangish tint. After you become familiar with the color characteristics of film (see page 124) and of light (see page 132), you can compensate so that the colors of your subject appear in your pictures just as you saw them in real life.

If you use black-and-white film, there are other considerations regarding color. The film records the *brightness* of various colors, which registers as shades of gray. Some colors, however, photograph in similar gray tones and blend together in the picture. By using various colored filters on the camera lens (see page 95), you can lighten or darken a color to increase the contrast between it and another color that normally produces a similar gray tone.

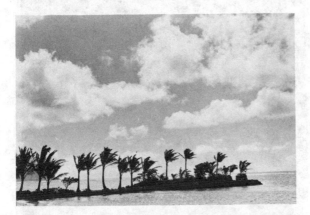

This tropical Hawaiian scene seems pretty enough when photographed in black-and-white without any filter.

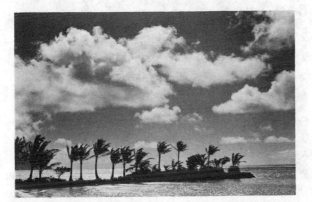

But the picture has extra impact when a yellow or red filter is used because it will darken the blue sky and makes the white clouds stand out. (A polarizing filter will do the same for color film.)

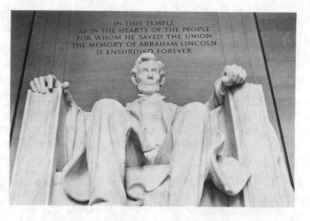

*How large is this famous statue at the Lincoln Memorial?*

*A good way to show its scale in a photograph is by including people, who serve as size indicators.*

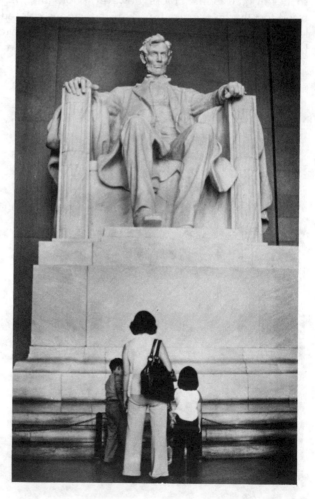

For example, in a scenic shot you include fleecy white clouds in a vivid blue sky. However, most black-and-white film is very sensitive to blue, so the sky will appear light gray in a photograph and look almost as bright as the clouds. If you use a yellow or red filter over the camera lens, the sky will appear a darker gray and there will be greater contrast between it and the clouds. The brightness of the sky and clouds will appear in the photograph more as you actually saw them. Whether you're shooting in black-and-white or color, when you look at the subject you want to photograph, always consider its color.

## Include Size Indicators

Ever look at pictures, especially scenic shots, and wonder how large or wide or tall the featured subject actually is? Solve this problem and improve those pictures by including a familiar object in the photo to help indicate the size of your main subject. For example, by including a person or animal in the scenic view, you give scale to a mountain or waterfall or whatever. These reference objects are called *size indicators*.

Also, you'll direct attention toward your main subject by using a size indicator in the foreground that's moving or looking toward the center of interest. Don't let the foreground figure face the camera or it will hinder, not help, your photographic composition.

Another time to consider including a size indicator is when you're shooting close-ups. For instance, if you wait patiently to include a bee or other insect in a close-up photo of unfamiliar flowers, you'll help show the relative size of the flowers and make a more interesting picture. Always be sure the size indicator you use has some natural relationship to the main subject and isn't something you just place in the picture to show scale.

## Try Fill-in Flash

Even when your composition is ideal, some part of the subject area may be in shadow or too dark. Often you can improve the picture by using *fill-in-flash*, especially when taking casual shots of people outdoors in bright sunlight. Shadows on faces or dark eyesockets caused by an overhead sun can be "filled in" with flash and thus eliminated.

Exposure is based on regular daylight exposure, because the flash is used only as fill-in light, not the main light source. Cameras with built-in or camera-controlled automatic flash are easiest to use for fill-in because they control the brightness of the flash automatically (check your camera's instruction booklet). For other types of flash units, you must figure the distance the flash should be from your subject for the correct amount of fill-in light. Details are given in the following section (see page 113).

The bright sun caused unpleasant shadows on the subjects' faces.

Fill-in flash added light to the shadowed areas and made a more pleasing picture.

## Break the Rules Now and Then

The various guidelines and suggestions for improving the composition of your pictures should become photographic habits after a while. But photography is not so serious that you always have to follow the rules. Have fun with your camera. Use your imagination and experiment. The results could be real crowd pleasers. At worst, you'll waste a few frames of film.

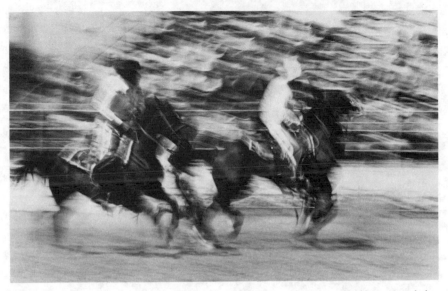

*Panning at a very slow shutter speed with galloping cowboys at a rodeo created this unusual photo.*

Remember to carry your camera wherever you go, and always be alert for ordinary subjects or situations you can turn into eye-catching photographs.

# Part II

## Taking the Worry out of Being Technical

# 1.

# Camera Operation

## *The Instruction Booklet*

One of your best friends for better photography is the instruction booklet that comes with your camera. If you didn't get one, threw it away, or discovered you don't read Japanese, ask at a friendly camera store to borrow an instruction

*Today's popular cameras include a great variety of 35mm single lens reflex (SLR) models.*

*Smaller 35mm range-finder models are favorites of some photographers.*

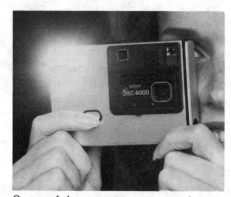

*Some of the newest compact and automatic cameras are Kodak's Disc models with built-in flash.*

*Auto-focus instant cameras have become more sophisticated and increasingly popular.*

manual for your model—then make a photocopy. Cameras are all the same in principle, but each brand and model has its own peculiarities. Pay special attention to the directions and warnings that are in **boldface** or *italic* type.

Even if you read the instructions carefully when you first bought your camera, reread them now and then—especially if you've been upset about your pictures. Most often the problems are not with your camera, but with the way you are using it. Claims about its simple operation are what help sell a camera

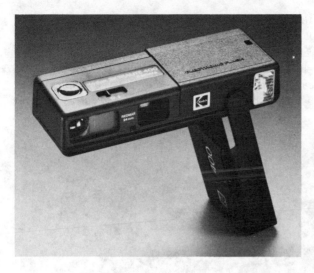

*Easy-to-operate pocket cameras, like this model with a built-in electronic flash, are used by many people.*

these days, but there are some specific directions and/or warnings you must follow that are not in the product's ads or sales brochures.

Here is a list of the key things to learn about your camera: (1) how to load and unload the film correctly; (2) how to adjust the automatic exposure system for the speed of the film you are using; (3) what number and size of batteries are required and how to replace them; and (4) how to connect and calibrate an automatic flash attachment (you're off the hook if the flash is built in).

## Loading and Unloading Film

So you've given up swearing? How about the time you'd been taking pictures on a cross-country vacation and then discovered there wasn't any film in the camera? All the tourists standing around you on the rim of the Grand Canyon had to cover their ears. Shame!

Of course, there's nothing to worry about if your camera is a pocket or instant model. The boys at Kodak and Polaroid figure you're the simple type. They've put little windows in their cameras so you can peek to see if there's a film cartridge or film pack in its proper place. If there is film, you'll see numbers in the window that tell you how many exposures have been made. And in case you've forgotten to look in the window, they've included an automatic gizmo that locks the shutter trigger so you can't take a picture unless there is film in the camera.

There's no pampering like that for 35mm camera fans. In fact, the camera makers try to deceive you. They put in a tiny window with numbers, called the *film frame counter*, that tells you how many exposures have been made. But

they don't mention that the counter works whenever the shutter is fired and recocked, *whether there is film in the camera or not.*

Cheer up! There is a way to tell if the camera is loaded. Just gently turn the *film rewind crank* in the direction of its arrow. If you feel tension after a few turns, there's film in the camera. If the crank turns freely, you're empty. Warning: You'll mess up this test if you press or turn the film rewind release button (more about this in a moment).

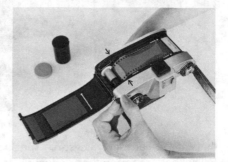

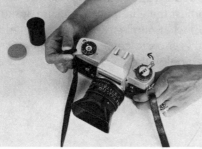

*To load a 35mm camera properly, place the film cassette in the film chamber and insert the film leader in a notch in the take-up spool. **Next,** cock and trip the shutter to advance the film until twin sprockets near the take-up spool (opposite arrows) are engaged in sprocket holes on both edges of the film. **Finally,** close the camera's back and advance the film until the film frame counter indicates frame No. 1. To check that the film is being advanced properly, gently take up the tension on the film rewind crank and watch that it turns (arrow) as you cock and trip the shutter.*

Another thing that's enough to make a grown person cry is having film in a 35mm camera but discovering it hasn't advanced. You take 36 pictures and don't make a single exposure. It's your own fault—you didn't load the camera properly. The trouble occurs when the *leader,* or tongue, of film from the light-tight 35mm cassette, is not inserted securely in the *take-up spool.* What usually happens is that you put in the film, close the camera back, and watch the film frame counter advance as you trip and recock the shutter. Meanwhile, inside the camera and out of sight, the leader has slipped off the take-up spool and the film never moves.

It's easy to avoid this common error. Keep the camera back open as you trip

and cock the shutter until you see that the *sprocket holes* on *both* sides of the film are securely engaged in the sprockets and that the film is being wound onto the take-up spool. Then close the back, fire off a few frames, and you're ready to shoot with the film frame counter on number 1.

*If you don't advance to No. 1 on the film frame counter before taking pictures, a portion of the first frame may have been exposed while loading the camera and you won't get a complete picture.*

As a final check that the film is advancing properly, take up the tension on the film rewind crank by winding it gently in the direction of its arrow until you feel definite resistance. Then, as you fire and recock the shutter, the crank should turn in the opposite direction to show the film is being drawn out of the cassette onto the take up spool. Simple, eh?

There's another problem that can upset 35mm camera owners. That's shooting an entire roll and then forgetting to rewind it before opening the camera back to remove the film cassette. "@%&! I exposed it!" Yes, you did. Some of the film may be ruined, but the degree of the damage depends on how long the camera back was open before you discovered your mistake and slammed it shut. Also it depends on the sensitivity (that is, the speed) of your film and the brightness of the light conditions. Yes, the film wrapper suggestion

to "load and unload the film in subdued light" is a good idea. With any luck you ruined only a few frames, so have the film processed anyway. Then vow *always to rewind the film into its cassette before you ever open the camera.*

And don't forget that to rewind 35mm film, you first have to press or turn the camera's *film rewind release button* in order to free the take-up spool. Otherwise you'll be fighting the rewind crank, shredding the sprocket holes, and scratching the film.

Had enough? Well, hold on, because here's one more thing for 35mm camera users to grieve about. It's not a doomsday situation, but be certain to remember whether the camera is loaded with a 36-, 24-, 20-, or 12-exposure roll of film. If you think you're using a 36-exposure roll but it's only 24 exposures or less, you might rip the film right out of the cassette when you're advancing the film and suddenly come to the end of the roll. This is most probable if you're heavy-handed with the advance lever, or you force advancement because you'll bet all the cameras in Japan that you've loaded a longer roll. Even if you have to fork over all your yen after tearing a shorter roll out of the cassette, don't give up. Find an understanding camera shop where the film will be transferred (in the dark) to another cassette, rewound, and made ready for processing.

## Exposure Systems—Automatic and Manual

If there's one thing that's responsible for the current boom in photography, it's the built-in *automatic exposure systems* in today's cameras. Forget about adjusting lens openings and shutter speeds; the age of automation is here. Now all you have to do is concentrate on composition—the camera does the rest. Well, almost. Taking technically perfect pictures still demands some of your attention.

Easiest to operate are the simplest (and least expensive) pocket and instant cameras. Unless you're really klutzy and cover the lens with a finger or block the *light sensor* that sets the exposure, you're bound to get a pretty good picture under daylight conditions. Here's why.

With simple pocket cameras, even though you might change from one type of film to another, the *film cartridge* has a code notch that automatically sets the exposure for the speed of the film you are using. With the popular instant cameras, only four kinds of film are available—SX-70 or 600 for Polaroid models, PR-10 or Kodamatic for Kodak models—and the cameras' exposure systems are preset for the speed of the particular film they use. (If an instant picture's exposure doesn't please you, there's a manual adjustment you can make on the camera to give your next shot more or less exposure.)

As for 35mm cameras, even the automatic exposure models, *you* must first

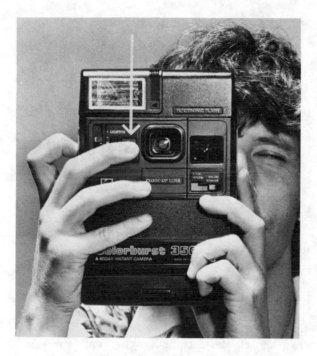

*Be careful not to block a camera's light sensor (arrow) with your finger, camera strap or case, or lens cap, because that will affect the camera's automatic exposure system and your pictures will be improperly exposed.*

range of speeds of film for 35mm cameras is much greater than it is for instant or pocket cameras. Now, what's all this about the "speed" of the film?

Lesson 1: A film's speed tells you how sensitive the film is to light. Some films are more sensitive than others. Their sensitivity is indicated by numbers, which are called *ASA numbers.* (Recently Kodak and other film manufacturers started calling them *ISO numbers,* too, but we'll use the traditional term—ASA—in this book; ASA and ISO numbers are identical.)

Lesson 2: You'll find a film's speed on its packaging box, the film cassette, its instruction sheet, and sometimes in the film name itself (Kodacolor 400, for example, has a film speed of 400).

Lesson 3: The speeds of popular 35mm films range from ASA 25 to ASA 400. The higher the number, the more sensitive the film is to light. (Read more about film later in this chapter.)

The Important Lesson: For proper exposures with a 35mm camera, you must set its *film speed dial* according to the ASA number of the film you are using. Unless you tell the camera how sensitive the film is, it cannot correctly make an automatic exposure or indicate the proper exposure with the camera's built-in exposure metering system. Whenever you put a new roll of film in your camera, remember to check its ASA and set that number on your camera's film speed dial. If you don't, and the new roll has a higher or lower ASA set the camera for the *speed of the film* you are using. The reason is that the

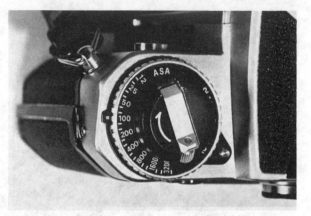

*A 35mm camera's expo-
sure system will work
properly only when the
film speed dial is set for
the speed (ASA) of the
film you are using. Here
the dial is set for film with
a speed of ASA 100,
such as Kodacolor II.*

number than the last film you used, your pictures will be overexposed or
underexposed.

Although some photographers couldn't care less, you probably want to
know how a camera's exposure system works. (Sure you do!) In a nutshell,
there are light-sensitive cells that measure the light—reflected or radiated by
your subject—as it comes through the lens or is received by a separate sensor
on the front of your camera. This activates a computer chip that figures and
sets the correct exposure by adjusting the shutter speed and/or lens opening
on cameras that feature automatic exposure.

On some 35mm models that require you to set the exposure manually, the
light-sensitive cells electrically activate a meter needle or glowing diodes (LEDs)
that indicate the shutter speed and lens opening to use for a proper exposure.
Sometimes exposures get botched up because you carelessly cover all or part
of the camera lens or light sensor with your hand, camera strap, or case. You'll
read more about combating exposure problems after learning something
about lens openings and shutter speeds.

## Lens Openings

Nobody has to tell you that light from your subjects comes through the camera
lens to make an image on the film. After the film is developed and printed,
there's your picture. For a proper exposure, however, the amount of light that
reaches the film must be controlled. This is done, in part, by adjusting the *lens
opening.* You'll often hear this called the *lens aperture. Lens diaphragm* is also
a proper term, but infrequently used.

The lens opening is adjusted manually by turning a ring on the lens; some
cameras make the adjustment automatically. In either case, overlapping metal
leaves within the lens change the size of the opening to control the amount of

light reaching the film. It's just like the iris that controls the light entering your eye.

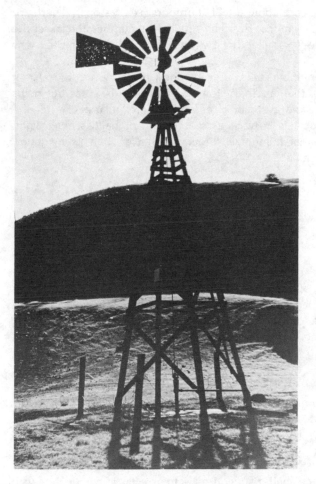

*The lens opening, or aperture, controls the amount of light coming through the lens to expose the film. A small lens opening was used to underexpose the film and create this silhouette of a windmill.*

How do photographers tell how much light is reaching their film? Someone came up with a series of numbers to indicate the relative size of the lens opening, and thus the amount of light. These are called *"f" numbers* or, more commonly, *f/stops*. You'll find them engraved on a ring around the lens. The "f" numbers you're likely to see on the lenses of currently popular cameras are 2, 2.8, 4, 5.6, 8, 11, 16, 22. There might be others, like 1.4 and 32. When there's a decimal point, the lingo to use is "five-point-six" or just "five-six"; never say "fifty-six."

Note: You won't find "f" numbers on the lenses of most simple or full-

automatic cameras because the lens opening cannot be adjusted manually. Also, don't confuse the "f" numbers on a lens with the numbers that indicate focusing distance.

Okay, why should you care about the "f" numbers (i.e., f/stops)? There are very good reasons. First, memorize this: The smaller the number, the larger the opening. That means, for example, that f/2 lets more light through the lens than f/22.

Not only that, the "f" numbers tell you exactly how much more (or less) light one lens opening admits than another. Don't get lost now, because this helps you in figuring how to avoid overexposures and underexposures. Here's the rule: Any adjacent f/stop lets in twice as much light, or half as much light, depending on whether that number is larger or smaller than its neighbor. You're ready for an example.

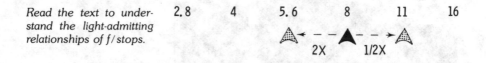

*Read the text to under-stand the light-admitting relationships of f/stops.*

If the lens opening is set at f/8, and you change it to the adjacent smaller number, f/5.6, the lens will let in twice as much light as before. On the other hand, if you change the lens from f/8 to the neighboring number that's larger, f/11, the film will receive only half the amount of light as previously. So what? Keep your motor running, because we'll be coming back to this wonderful fact of photo life.

## Shutter Speeds

As luck would have it, the lens opening isn't alone in controlling the amount of light that reaches your film. Its co-conspirator is *shutter speed*. The shutter speed setting determines how long the light that comes through the lens will register on your film. If the shutter speed isn't set correctly, in conjunction with the lens f/stop, your pictures will be overexposed or underexposed.

Shutters are built in the lens or in the camera body. If you have a camera that allows the lenses to be changed, such as one of the popular 35mm single lens reflex (SLR) cameras, the shutter is built in the camera. It's a sturdy curtain of metal or cloth and is called a *focal plane shutter*. On those models, and many others, the shutter speed control dial is located on the camera body. On cameras equipped with a lens that cannot be removed, you'll find a shutter speed adjustment ring on the lens itself. A shutter built in a lens is a circular series of overlapping metal leaves and is called a *leaf-type shutter*.

On simple pocket cameras, the shutter speed is set automatically when you

insert the film cartridge. On pocket and instant cameras with automatic exposure systems, their light-sensitive cells and computer chips determine and set the shutter speed. Some 35mm cameras are fully automatic and set both the shutter speed and lens opening (i.e., the f/stop). Other automatic 35mm models require you to preset one or the other exposure control, either the shutter speed or f/stop. On manual 35mm cameras, you must set both shutter speed and f/stop.

You know that shutter speeds help determine exposure. The second big role they play is giving you the opportunity to reveal the action of your subjects. Action really adds impact to pictures and often makes the difference between a snapshot and a great shot. For stop-action, which means "freezing" your subjects so they can be seen in sharp detail, you use a fast shutter speed—say 1/250 to 1/1000 second. To blur the action, depicting your subjects so their movement is obvious or even exaggerated, you select a slow shutter speed,

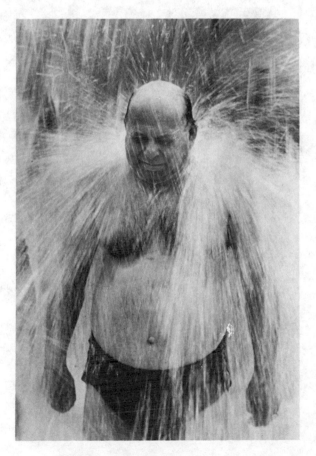

*A slow shutter speed shows the thermal water splashing off this German bather at an outdoor spa.*

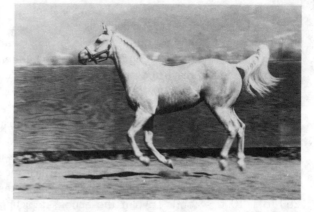

*A shutter speed of 1/60 second was used while panning to stop the action of this running horse with all his feet off the ground.*

*Using a flexible cable release helps avoid camera movement at slow shutter speeds or during time exposures.*

such as 1/30 to 1/2 second, or longer. Go back to the first part of this book to review the various ways to show action in your pictures. (See page 33.)

For *time exposures* longer than 1 second, your camera may have a shutter position marked "B." If it does, you can turn the shutter speed dial or ring to B, then press and hold the shutter release button to keep the shutter open as long as you wish. To close the shutter, just lift your finger from the shutter release.

Of course you may accidentally move the camera while holding in the shutter button, or just get tired of pressing it. A *cable release* is the answer. It is a short flexible cable with a locking plunger that is attached to the camera's shutter release. You press the plunger, lock it in place, and let go. The shutter will stay open until you release the lock.

Ready for a revelation that will help you combat overexposures and underexposures? Changing from one shutter speed to an adjacent shutter speed will either double the amount of light reaching the film, or cut it in half—depending on whether you move to a slower shutter speed or a faster one. For example, if your shutter speed is 1/125 second, change it to the adjacent slower speed, 1/60 second, and the film will be exposed twice as long and thus will receive twice as much light as before. Or if you switch from 1/125 second to its neighboring speed that's faster, 1/250, the film is exposed only half as long and thus with half as much light as previously.

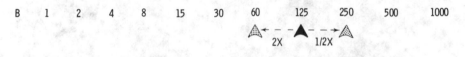

*Read the text to understand the light-admitting relationships of shutter speeds.*

That's nice to know, but why should you care? Hopefully a light has flashed in your head and you now realize the interrelationship between lens openings and shutter speeds. Just to be sure, here's a little review.

Changing the shutter speed to its adjacent slower shutter speed—as from 1/125 to 1/60 second—gives the film twice as much exposure. And if you change the lens opening to its adjacent smaller opening (i.e., larger "f" number)—as from f/5.6 to f/8—the light reaching the film is cut in half. So, if you change the lens opening and shutter speed *at the same time,* as just described, the exposure will be the same as before! That means an exposure of 1/125 second at f/5.6 is identical to an exposure of 1/60 at f/8. Other shutter speed-f/stop combinations have the same relationship and produce identical exposures. Study the accompanying illustration.

What good is all this information? It makes you a better photographer because you now realize that if you switch to a slower shutter speed, you need to make the lens opening smaller—or you'll take an overexposed picture. Like-

As this illustration shows, various shutter speed and f/stop combinations give the same exposure as 1/125 second at f/5.6. For example, 1/60 second at f/8, or 1/1000 second at f/2, expose film with the same amount of light as 1/125 second at f/5.6.

wise, if you switch to a faster shutter speed, you must make the lens opening larger—or get an underexposed picture.

Well, why not just stick with one shutter speed, or let the camera's automatic exposure system take over? Not bad ideas, some of the time. But if you're

The size of the lens opening determines depth of field—how much of the picture area will be in focus. Here a large lens opening is used, f/4, and only the boy in front is in sharp focus.

When a small lens opening is used, f/16, depth of field is greater and the other children also are in sharp focus.

going to improve your photography, you must understand and be in control of the exposure. Already you know that shooting at the same shutter speed isn't always the best decision. For instance, how are you going to stop the action or blur it if you don't change the shutter speed? Lots of folks use 1/125 second as their "standard" shutter speed, and that's a good choice, but it will limit your creativity. Besides, why pay for all the other shutter speeds if you don't intend to use them? Better buy the simplest pocket camera and put away your 35mm SLR.

It's also important to understand and be able to control the lens opening. That's because the f/stop you choose not only helps determine exposure, it has a lot to do with how much of your picture will be in focus. That concept is called *depth of field*. Snapshot photographers don't think about it. Better photographers always do.

The rule is this: The smaller the lens opening, the greater the depth of field—which means more of your picture, from foreground to background, will be in focus. And the converse is also true: The larger the lens opening, the less depth of field—less of your picture, from foreground to background, will be in focus. The value of depth of field should be obvious. If you want people to see more of the subject in sharp detail in your picture, use a small lens opening. If you want just a certain part of the subject to be in focus, and thereby make it stand out in your picture, use a larger lens opening. More about depth of field in a moment.

## Focusing Mechanisms

One of the biggest bugaboos for some photographers is getting pictures in focus. Of course the problem is easily solved by using a pocket or other simple camera with *fixed focus*. That means everything will be in focus beyond a certain point. But take this advice: In the camera instruction booklet for a fixed-focus camera, find the *closest* distance a subject will be in focus, and memorize it. Let's say it's 4 feet. If you get any closer to your subject than that, you're going to get an out-of-focus picture.

By the way, when you look at your pictures, don't confuse images that are not in focus with those that are fuzzy because of two other reasons: You moved the camera when you took the picture, or the subject is blurred because your shutter speed was too slow to stop its action.

Some cameras, including instant and 35mm models, now feature *auto-focusing*. You slightly depress the shutter release button and a motor activates the focusing mechanism until the subject in the center of your viewfinder is in focus. Then you fully press the shutter button to take a sharp picture. A miracle!

Maybe. The camera really doesn't know what your main subject is, so what

*The round honeycombed area on this instant camera is a sound-sensing device that activates a motor to focus the lens automatically when the shutter button is pressed.*

you're interested in may be out of focus in your picture. For instance, the camera can wrongly focus on an object that is in the foreground instead of the real subject. Warning: You must read and follow explicitly the directions for any auto-focus camera. You'll also learn from the camera instruction booklet—and experience—when it's best to override the auto-focus mechanism (if possible) and adjust the focus manually for the sharpest possible picture.

What about focusing cameras that don't feature auto-focus or fixed focus? As you know, they have a *lens focusing ring* which you turn to put your subject in focus. Simple models use something called *zone focusing* and feature symbols on the focusing ring instead of distances in feet and/or meters. The symbols represent subjects at varying distances—very close, nearby, far away. Often the symbols are an outline of a single head (to indicate the focus setting when you're shooting a portrait), heads and shoulders of three persons (the focus point for group shots), and a mountain outline (for scenics). Easy enough.

More precise focusing is possible with cameras that show you what's in focus in the viewfinder. Some models feature *rangefinder focusing.* You'll see distinct split or double images of the subject in the viewfinder, until you turn the lens focusing ring and the twin images come together. Then you know the subject is sharply focused.

With other cameras, like 35mm single lens reflex models, the subject will look fuzzy in the viewfinder until you turn the lens focusing ring and the image appears in sharp focus. Always focus sharply in the viewfinder on the most important thing in your picture—what you want people to notice more than

(A)

(B)

(C)

*In comparing camera focusing systems, rangefinder cameras show a twin or split image (A) when the subject is out of focus. Viewfinders of reflex cameras, however, show a fuzzy image (B), which often is exaggerated in a center circle. With either type of camera, the subject is in focus when it appears sharply defined in the viewfinder (C).*

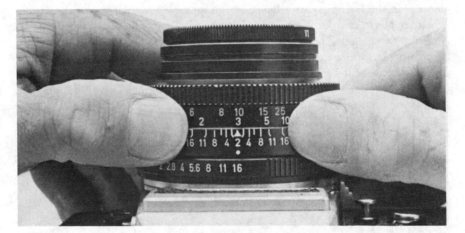

*The depth of field scale on a lens, represented by opposing pairs of f/stop numbers, shows you the limits of the picture area that will be in focus. In this example, with the lens opening set at f/16, look opposite the 16s on the depth of field scale to the distance numbers on the lens focusing ring (top numbers are feet; bottom numbers are meters). As you see, with the lens focused at 10 feet, everything between 6 feet and 25 feet will be in focus.*

anything else when they look at the photo.

Lens focusing rings usually are engraved with numbers that indicate distances in feet, and sometimes in meters. So another way to focus, without using the viewfinder, is to estimate or measure the distance between the camera and your subject and set the lens focusing ring for that distance.

On some lenses, usually those for 35mm cameras, you'll see even more

numbers. Don't be surprised that they're in pairs and are identical to the f/stop numbers. They make up the *depth of field scale*—something that many photographers don't even care about. You should. By using the depth of field scale you can tell exactly how much of your picture will be in focus even before you take it. Here's how.

After you've focused on your subject and set the exposure controls, note the f/stop you are using. Even if the camera sets the exposure automatically, check which f/stop was selected. Now find the same "f" number on the depth of field scale. Look for matching numbers on either side of the focus mark.

Can't find the numbers? On some lenses, like those made by Nikon, look for color-coded lines instead. They're identical to the colors of the "f" numbers on the lens opening control ring (pink, white, green, yellow). Also, on some lenses there is no room to engrave all the numbers on the depth of field scale. For instance, you might only see 2, 4, 8, and 16. You'll have to imagine the other missing numbers (2.8, 5.6, 11) are between the engraved numbers, in the same order they appear on the f/stop control ring.

Now what? From the depth of field scale, after you find the two numbers identical to the f/stop you are using (or imagine where they should be), look exactly opposite each of them to the distance scale on the lens focusing ring. Note the two distance numbers, which represent feet. This is the range from your camera, from one distance to the other, that will be in sharp focus in your picture. Honestly! It's a law of lenses, or something like that. The fact is that before you ever see the printed picture, you'll know how much of the subject area, from foreground to background, will be in focus.

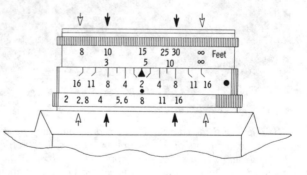

*The depth of field scale on a lens indicates how much of the picture area—from foreground to background—will be in focus. When this 50mm lens is focused at 15 feet and its opening is f/8, everything from 10 to 30 feet (black arrows) will be in focus. If the lens is changed to a smaller opening, f/16, depth of field increases and everything from 8 feet to infinity (∞) will be sharply focused (white arrows).*

Here's an example to study with the accompanying illustration. Say your 35mm camera has a 50mm lens and is focused on a subject 15 feet away. The lens opening you're using is f/8. Find the pair of 8s on the depth of field scale. Look directly opposite them to the distance scale on the lens focusing ring. The numbers you see, 10 and 30, tell you that everything between 10 and 30

feet from your camera will be in focus. Easy, eh? (It becomes clear with practice!)

If you've been wondering what that elongated or lazy figure 8 means on the lens distance scale, it represents *infinity*. That's the distant point in your picture subject area beyond which everything will be in focus.

Of course you probably noticed there isn't room to engrave numbers on a lens for the full range of distances. So if a footage number is not opposite a depth of field number, just figure the distance by noting the adjacent distance numbers. Let's say one of your depth of field numbers points to a blank space between footage numbers 10 and 15 that are engraved on the distance scale. All you do is figure if the depth of field number is closest to 11, 12, 13, or 14 feet.

Ready for some other facts regarding depth of field? First, let's hope you haven't forgotten that depth of field changes whenever you change the size of the lens opening. As mentioned earlier, more of your subject area will be in focus when you use a smaller lens opening. So it stands to reason that less of the subject area will be in focus when a large lens opening is used.

*The closer your point of focus, like this fender light 5 feet from the camera, the less depth of field; only the lights and a little of the hood of the first car are in sharp focus.*

*When the point of focus is farther away—20 feet in this photo—depth of field increases; two cars—the second and third—are now in sharp focus. The same lens opening, f/4, was used for both pictures.*

Another thing to know is that depth of field changes when you change the point of focus. Even if your lens opening stays the same, the depth of field will

be different if your point of focus is different. For proof, figure the depth of field on your normal lens when it is focused at 5 feet and then 20 feet, using the same lens opening, such as f/5.6. You'll notice that the depth of field is greater when you are focused at a greater distance. And, conversely, that means less of your subject area will be in focus the closer your point of focus is to the camera.

Finally, just one more point to ponder about depth of field. Depth of field is different for different types of lenses. A wide-angle lens will give you greater depth of field than a telephoto lens. Just check their depth of field scales and compare. More about this when it's time to talk about lenses.

By reading this section and studying the illustrations—and carefully following your camera's instruction booklet—you should have an understanding of camera operation that will make you a better photographer. At least you know more about loading and unloading film, camera exposure systems, lens openings, shutter speeds, and focusing mechanisms. But none of this is worthwhile if your pictures don't come out. Often the most frustrating technical problem is exposure. Your photos are too dark or too light or sometimes there's no image at all. Let's review common exposure troubles and hear some solutions.

# 2.

# Exposure Problems

## No Exposure

You know the scenario. You've taken pictures on a vacation trip or during graduation day or of your daughter's wedding. You sent them to the processor and can't wait to see the results. Later, you eagerly open the envelope with the prints, or the box with the slides, and—disaster! Some of the pictures are too light or too dark, and a few have no image at all. What happened?

Rather than give up photography or take potluck again the next time you shoot, it's time to find out what went wrong with your exposures. Consider the following exposure problems to discover which of them might be the guilty gremlins.

First, remember not only to look at your prints but to inspect the negatives too. Is there any exposure at all? Some processors don't print poor negatives, so check them carefully to see if there is any trace of an image. If there's absolutely no image on the roll of film, not even the lines that normally outline each frame, the roll has not been exposed at all. The fault is usually yours. Either you didn't load the film properly and it never wound through the camera, or you mistakenly sent an unexposed roll to the processor. (The negatives from an unexposed roll of print film will be clear, while the slides from an unexposed roll of transparency film will be dark.)

To avoid the first and most common problem, follow the film-loading directions in your camera booklet and also the advice given earlier in this section. To make sure you don't have an unexposed roll processed, 35mm camera users should always rewind an exposed roll *entirely* into the cassette. That way, whenever you pick up a 35mm film cassette with its leader or tongue hanging out, you'll know for certain that the roll has never been exposed and should not be processed.

[ 69 ]

*Blank or incorrectly exposed negatives or slides may be caused by a faulty automatic exposure system; when you're having the camera checked, be sure to show the repair person those negatives or slides to help him diagnose the trouble.*

There is a remote chance that an entire roll of film is blank because the camera's shutter is broken and did not open. Or it may be stuck in an open position. There's also a possibility, on 35mm single lens reflex models, that the fault is with the mirror which reflects the image from the lens to the viewfinder. The mirror is supposed to move out of the way when the shutter release button is pressed. If it doesn't, the film will not be exposed. In the case of a faulty shutter or mirror, you'd probably notice that something seemed wrong at the time you were taking the pictures; the camera didn't make its usual sounds. In any case, take your camera to a repairman.

If just one or only a few frames on a roll of film show no exposure, you may have forgotten to remove the lens cap. The light might also have been blocked by the camera case, or covered up by your hand. You won't have these problems with a 35mm single lens reflex camera, because there is only one lens and you'd notice in the viewfinder if something was blocking it. Be careful with other cameras because there is one lens for the viewfinder and another for the film. While the subject you see in the viewfinder may appear unobstructed, the lens for the film might accidentally be covered. Check it before you shoot.

Another reason negatives or slides may appear blank is a faulty automatic exposure system. Most times an automatic exposure system malfunctions because the camera batteries are dead. This should be apparent even before you

take the picture; some models have a safety feature that locks the shutter release button when the batteries aren't working. (Frequently the batteries are not exhausted but merely have some invisible chemical corrosion that prevents proper contact. Before replacing batteries with new ones, wipe them with a cloth to remove possible corrosion and try them in the camera again.)

Sometimes the reason for no apparent exposure of a film frame is that you set the shutter speed too fast or too slow, or the lens opening too large or too small. The result is *extreme* overexposure or underexposure that prevents any image from registering on the film.

Problems with a flash also can cause a film frame to have no image. A common trouble is that the flash doesn't fire. The reason? The flash unit isn't turned on, or its batteries are dead, or the flash connecting cord is broken or not plugged into the camera. For instant and pocket cameras that use flash-cubes or flashbars, one or more of the bulbs within the flash pack may be faulty, or the pack wasn't inserted in the camera properly and didn't make contact. Regardless of the type of camera, your flash pictures may also be blank because the shutter was not correctly set to synchronize with the flash; it fired before or after the shutter was open. Your camera instruction booklet will tell you what shutter settings to use with flash.

Finally, there's a chance your roll of film appears unexposed because of problems during processing. An honest processor will admit it's the company's fault so you won't blame your camera. However, any liability usually is limited to the replacement of your film with a new roll; there's no way to recover the pictures you lost except to reshoot them.

## Underexposure

Pictures that are too dark are a real turnoff. It's difficult to see any detail in your subjects, especially in shadow areas, and everything looks too somber. What went wrong? Sad to say, there are all sorts of things to blame for under-exposed pictures. Study your slides and prints and try to remember what might have happened at the time you were shooting.

A film that's underexposed has not received enough light through the lens to make a proper image. The shutter speed could have been too fast a speed, or the lens f/stop at too small an opening, or both. If you manually set the exposure, be sure the light hasn't changed—as when the sun goes behind a cloud—between the time you make an exposure meter reading and adjust the shutter speed and lens opening.

Also, don't become a victim of one of the most common reasons for under-exposure—you weren't paying attention and aimed your camera at a bright part of the picture area when you made the exposure reading. This frequently occurs with hand-held exposure meters, too. If you're not careful, the meter

*When the background is bright, get close to your subject to make an exposure reading so that the subject won't be underexposed like this fisherman.*

reads a bright sky instead of your actual subject, which is probably darker. This results in your subject's being underexposed. Always aim your camera or hand-held meter so it makes an exposure reading of the most important part of your picture. If your subject is surrounded by bright areas, such as snow, move in close to make an exposure reading of just the subject itself and avoid underexposure.

Another possible reason for underexposed pictures is that the film speed dial on your camera may have been set at a higher, incorrect ASA number. That would calibrate the camera's automatic exposure system or built-in exposure meter for a more sensitive film than you actually used. Always remember to check or reset the film speed dial when loading a new roll of film. As you use the camera, also check the dial now and then, because it may slip or accidentally be turned to a wrong ASA number.

There's also a chance the metering system has been damaged and is indicating or making incorrect exposure settings.

Simple as it sounds, a common reason for underexposure is simply that there isn't enough daylight to make a good picture with the film you are using. Basic pocket models preset exposure, depending on the speed of the film that's put in the camera. On dark days and other times when the light level is low, use a faster film, like Kodacolor 400 (ASA 400) instead of Kodacolor II (ASA 100). Polaroid and Kodak instant cameras have a lighten-darken control you can adjust to correct underexposures or overexposures.

*If you don't pay attention to the maximum range of your flash, the light may not be strong enough to reach your subjects and they will be underexposed, like these musical entertainers.*

When you use flash, there are other "opportunities" for underexposure. Guess what photographers do most? Get too far from their subjects. The flash just isn't strong enough to reach the subject and make a proper exposure. To avoid underexposed flash pictures, read the flashbulb package or the flash unit's instruction booklet and memorize the *maximum* distance your subjects can be from the flash. For cameras equipped with built-in flash, read the camera instruction manual to learn the maximum range of the flash.

Underexposed flash pictures can also occur if the flash batteries are weak or the flash unit has not had enough time to fully recycle after the previous flash. Usually there's a little light on the flash unit or camera that glows when the flash is ready to fire. Wait for it. If it takes a long time to glow after the flash has been fired, replace or recharge the batteries. The flash or camera instruction booklet will give the normal recycle time for your flash unit. (Also see page 106.)

Like regular daylight exposures, flash pictures can be underexposed if the lens opening and shutter speed are not set correctly. The shutter must be synchronized to be fully open when the flash goes off. Check your camera manual for the exact shutter speed to use. The f/stop you select depends on the distance of the flash from your subject. A chart on the flash unit or flashbulb carton indicates the correct lens opening to use. If the camera is set with a f/stop that's smaller than the one indicated, underexposure is often the result.

## Overexposure

Overexposure is the obvious opposite of underexposure, but the results are the same—disappointing pictures. Overexposed images are too light and look washed out. Your subjects don't have much detail or color. What happened?

Film that is overexposed received too much light. Most often the shutter speed was too slow, or the lens opening too large, or both. Sometimes a light-colored subject is surrounded by a very dark area, and your exposure meter makes an incorrect reading. To avoid overexposure of the subject in such cases, move in with your camera or hand-held meter to make an exposure reading of only the light-colored subject.

If your camera has an automatic exposure system, a common reason for

When the background is dark, get close to your subject to make an exposure reading so that the subject won't be overexposed, like these two souvenir shoppers in Mexico.

overexposures is accidentally blocking the camera's light-reading sensor with your hand or the camera strap. The sensor thinks the light conditions are darker than they actually are. The same thing can happen with an automatic flash unit that has a light sensor to control flash exposure.

Also be careful with any camera that has a built-in exposure meter, even if it doesn't feature automatic exposure. Blocking the camera's light sensor will foul up the readings and lead you to set an incorrect shutter speed or f/stop that causes overexposures. This won't happen with 35mm single lens reflex models, because their exposure meter readings are made through the main camera lens, and you'd notice in the viewfinder if something was blocking the lens and the light.

As you were warned earlier, always check that the film speed dial on your camera is properly set for the speed (ASA) of the film you are using. If it is set on a number that's lower than your film's actual ASA, you can expect overexposed pictures, because the camera's exposure meter or automatic exposure system will be calibrated for film that is less sensitive to light than the film you are actually using.

Sometimes you'll get overexposures because light conditions are very bright, as during a sunny day on the beach or ski slopes, and you're using a very sensitive film (that is, one with a high film speed, like ASA 400). Not all cameras have the fast shutter speed or small lens opening that may be required to avoid overexposed pictures in such situations. Some warn you in the viewfinder with a tiny signal light or exposure meter needle in a caution zone that overexposure is going to occur. One solution is to cut down the amount of light

*If you don't pay attention to the minimum distance your flash must be from a subject, the light will be too strong and your subject will be overexposed.*

reaching the film by attaching a filter to the lens, such as a polarizing filter (*see* page 94).

If your flash pictures are overexposed, chances are the flash was too close to your subject. This occurs most often with simple, nonadjustable cameras. Read the camera or flash instruction booklet to learn the *minimum* distance the flash must be from the subject. If you are ever closer than that distance, here's a tip: Drape a clean white handkerchief over the flash to cut down the amount of the light and avoid overexposure. With adjustable cameras, another reason for overexposed flash pictures is that the f/stop was set incorrectly and was open too wide. Carefully study the charts on the flash unit or flashbulb carton to figure out the correct lens opening to use, which depends on the distance your subject is from the flash.

## Weird Exposures

For most photographers, overexposures and underexposures top the list of technical calamities. But once in a while you get some exposures that are just plain weird—and downright puzzling. Here are descriptions of those picture problems, along with causes and cures.

If the picture image seems misty, you can bet the camera lens is dirty. Be sure to check not only the front surface of the lens, but the rear lens element

*The most effective and safest way to clean lenses is with liquid lens cleaner and lens cleaning tissue. Clean the rear lens element, too; this is easily done with 35mm single lens reflex (SLR) cameras by removing the lens.*

inside the camera. Make certain there is no film in the camera before you open the camera back. (Lenses on single lens reflex cameras can be removed from the camera body for easier cleaning.)

Clean lenses safely with *liquid lens cleaner* and *lens cleaning tissue,* both available at camera stores. If you don't have the liquid lens cleaner, breathe on the lens (no spit, please). If you don't have lens cleaning tissue, use a clean and *soft lintless* cloth, like chamois or silk. Never use the tissues designed for eyeglasses, because chemicals in those tissues can be harmful to the special coating on camera lenses.

Occasionally a picture looks misty for other reasons. Sometimes moisture condenses on the camera lens or on the film while it's in the camera. You can expect this to occur on a cold winter day when you bring the camera into a warm car or building after you've been outside. It can also happen in a hot climate, if the camera suddenly gets warm, as when you're vacationing in the tropics and emerge from an air-conditioned hotel into the humid outdoors. Allow time for any moisture that condenses to evaporate before you take a picture—unless you like misty images.

*Round or hexagonal bright spots in a picture are caused by lens flare, which occurs when a bright light shines into the lens. This photo of a hot air balloon was taken directly into the sun.*

Sometimes you'll notice strange light streaks or spots in your pictures. Most often this is the result of sunlight or reflected glare that shines directly on your camera lens and causes what's known as *lens flare*. Be careful of this when you're shooting toward the sun or reflective subjects, like a lake, that can bounce the bright light into your lens. Lens flare can appear as a round or hexagonal spot of light. The size and shape depends on the f/stop you used and the design of your camera's lens aperture. Sometimes there are multiple flare spots, which occur when the sun or glare strikes several of the glass elements inside your lens.

Avoid these problems by using a *lens shade* to shield your lens, or block out the light with your hand or some other convenient sun shade. Watch out that your hand isn't included in the picture. Another way to avoid lens flare caused by reflected glare is to use a *polarizing filter* on your lens. You turn the filter to reduce or cancel out the offending light rays. More about this useful filter later.

Lens flare, as you might be aware, is not always bad for your pictures. In fact, it goes in and out of fashion with photographers; some professionals purposely

*Accidental double exposures, like this one, can occur when the film is loaded im-properly, the film advance mechanism is faulty, or you force extra shots at the end of the roll.*

use lens flare for its eye-catching or dramatic effect. You can experiment with it too.

Light streaks in your pictures also can be caused by a light leak in your camera. The camera may have been dropped and damaged, or the camera back may not have been closed securely. Light gets in and exposes the film in streaks or spots. In black-and-white pictures these will show up gray or white, while light leaks in color pictures frequently show up in orange or yellow. If you notice light streaks in your photos, inspect your camera carefully or take it to a camera repairman with your ruined pictures for examples.

Finally, don't forget that film can sometimes be "fogged" when you load or unload your camera in direct sunlight. The bright light sneaks into the film cartridge, cassette, pack, or roll and causes light streaks or bizarre colors in your pictures. The simple solution is to shade your camera and film when you are loading or unloading.

Another picture puzzler can be fuzzy black spots that show up in odd shapes and positions. Chances are there is some unsuspected object inside your camera. It could be an insect or a broken piece of film or some other bit of debris that got into the camera chamber when you were loading or unloading the film (or changing lenses on a single lens reflex camera). Carefully inspect the inside of your camera when the film is removed. Shake the camera to dislodge any hidden debris, but don't poke around haphazardly or you might damage its internal mechanisms.

If a photo ever seems to be two in one, it's probably just that—a *double exposure*. Most modern cameras are designed to prevent double exposures, although a few have a special feature that permits deliberate ones. When it happens accidentally it's usually because the camera's film advance is faulty or because you tried to get another picture on the film at the end of the roll. Whenever the film advance lever is hard to cock, don't force it. The film is either jammed in the camera or you've come to the end of the roll. (Did you load a 20-exposure roll thinking it was 36 exposures?) Rewind the film, or take your camera to a camera store and ask for help.

# 3.

# Lens Selection

## Types of Lenses

Some photographers think that the more lenses they have for a camera, the better photographer they will be. That may be true—at least in the sense that a variety of lenses gives you more flexibility when you're taking pictures. But the different types—wide-angle, telephoto, zoom, macro—will be worthwhile only if you know how and when to use them.

First, let's praise the simple pocket, instant, and other cameras that are equipped with a single permanent lens. You can't change the lens, so there's one less thing to think about when you're taking pictures. Also, permanently

*Some instant cameras, as well as pocket cameras like this model, have built-in lenses that can be switched from normal to telephoto or close-up to make your subject appear larger on the film.*

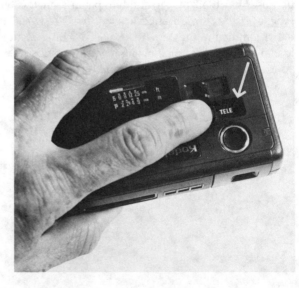

attached lenses usually are of the "normal" type, which means they "see" your subjects in the same perspective as your own eyes do—so it's easy to visualize a possible picture even before you look through the camera's viewfinder. (By comparison, wide-angle lenses reduce subject size so more can be included on the film; telephoto lenses enlarge subject size.) Many cameras that have a permanent lens offer some flexibility because they can be fitted with accessory lens attachments for close-up pictures, as you'll read later. And some pocket cameras can be switched from a "normal" to a "telephoto" mode.

Most versatile, however, are the cameras designed for interchangeable lenses. Especially popular are the 35mm single lens reflex (SLR) models, because they can be equipped with a great variety of lenses available from the camera's maker and independent lens manufacturers.

First, a warning: The lenses you attach must fit perfectly. Not only must the lens and camera mounts match, but their internal connections must align exactly in order for the camera's automatic exposure or metering system to work properly. Never force a lens onto a camera because it looks as if it should fit. Ask at a camera store if the lens is designed to be mounted on your camera model. There are two basic types of camera mounts. The better one is the *bayonet mount,* because it permits you to change lenses quickly with a simple twist or turn of the lens. The other type, the *screw mount,* takes more time and skill, because you must align the threads of the lens and the camera body and then turn the lens several times to attach it.

Camera lenses are known by general names, like wide-angle and telephoto, but how do you tell what each one does specifically? You'll find the answer engraved on the ring around the front lens element. It's a number, called the *lens focal length,* that's given in millimeters. You'll see it identified by the millimeter abbreviation, mm. Sometimes it follows another number that identifies the largest f/stop opening on the lens, such as 1.4/50 (the maximum lens

*35mm single lens reflex (SLR) cameras can be equipped with a variety of lenses, including wide-angle and telephoto types.*

opening is f/1.4, and the lens focal length is 50mm). Occasionally, on older lenses, the focal length is given in centimeters (cm); you can multiply that number by 10 to determine what it is in millimeters (mm).

What's so important about the lens focal length number? It gives you an idea of the size the subject's image will be on the film. The rule is this: The larger the lens focal length number, the larger the subject's image size appears on the film. The numbers are proportional, too. For example, a 180mm lens makes an image that's twice as large as the image made by a 90mm lens.

Focal length also is an indication of the subject area that will be covered by a lens, which is called its *field of view* or *angle of view*. The smaller the lens focal length number, the wider the field of view. Lens charts are available that tell you the exact angle of view (in degrees) for various lens focal lengths.

*The subject area covered by a lens, which is called its angle or field of view, is figured in degrees (°) and varies according to the focal length of the lens. In this example of lenses for a 35mm camera, a 35mm (wide-angle) lens has an angle of view of 63°, a 50mm (normal) lens covers a 45° angle, and a 135mm (telephoto) lens has a field of view of only 18°.*

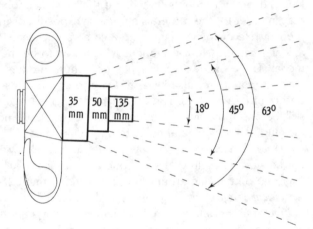

Lenses for 35mm SLR cameras currently range in focal length from 6mm to 2000mm. The *normal lens* (sometimes called *standard lens)* for a 35mm camera has a focal length of 50mm, although it can vary by a few millimeters depending on your camera model.

When the focal length number is less than the normal 50mm or so, the lens has a wider field of view and is considered a *wide-angle lens.* Popular wide-angle lenses for 35mm cameras are of 35mm, 28mm, 24mm, and 21mm focal lengths. Since wide-angle lenses cover a greater area than normal lenses, the subject's image size will be smaller on the film.

On the other hand, any lens with a focal length number larger than the normal 50mm or so has a narrower field of view and is called a *telephoto lens.* Popular telephoto lenses for 35mm cameras are of 90mm, 105mm, 135mm and 180mm focal lengths. Since telephoto lenses cover a smaller area than normal lenses, the subject's image size will appear larger on the film.

Shooting with lenses of different focal lengths from the same camera position changes the size of your subject on the film. For this overall view of an abandoned building and wagon on the Nebraska plains, a 35mm (wide-angle) lens was used.

Photographed with a 50mm (normal) lens.

Photographed with a 135mm (telephoto) lens.

What's the practical value of understanding focal length? Well, if you want to include more of the subject in your picture without moving farther away, you

know to change to a wide-angle lens. Then if you put on a wide-angle lens, say a 28mm, and discover you still can't include everything you want in your picture, you know you should change again to a lens with an even smaller focal length number, like 24mm or 21mm. Or, if you want to capture just a small part of the subject in your picture without moving closer, you know you should use a telephoto lens. And if you put on a telephoto lens, say a 90mm, but find it still includes too much of the subject, then you know to change to another telephoto with a larger focal length number, like 105mm or 180mm.

Besides the differences in image size and field of view, you should know some of the other characteristics of wide-angle and telephoto lenses.

*Telephoto lenses allow you to fill up the viewfinder (and thus the film frame) with your subject without moving the camera closer.*

If you're like most photographers, you will probably buy a *telephoto lens* before you get a wide-angle. Everyone seems to like big images instead of small ones. Also, many photographers seem hesitant or too shy to get close to their subjects. A telephoto lens is an easy out—you can fill the film frame without going near the subject. That's fine, but beware of telephoto troubles.

Blurred pictures are common. Telephoto lenses exaggerate the size of the subjects—that is, they make insects larger than you can see them with your own eyes—but they also exaggerate any camera movement, and camera movement blurs the image. Also, a telephoto is larger and heavier than a normal or wide-

angle lens and it may be harder for you to hold steady. One way to prevent such blurring is to use a faster shutter speed to cancel the effect of any camera movement that might occur because your arms are tired or your hands are shaky.

A guideline you can follow is to use a shutter speed that's equal to or faster than the millimeter number of the telephoto lens on your camera. For instance, if you're shooting with a 180mm lens, set the shutter speed at 1/250 second or faster. You also can avoid camera movement and blurred pictures with a tele- photo lens by using a tripod to support your camera. With lenses of very great focal length, from 300mm up, it's a must.

Another thing to consider is that depth of field is less with a telephoto lens, so it is important to be sure you've focused sharply on your subject. On the plus side, because of its limited depth of field, a telephoto is a good lens choice when you want to make your subject stand out by isolating it from the background.

Of course, an important benefit of shooting with a telephoto is being able to photograph subjects when you can't get close to them, like the players in a football game or the birds that visit the feeder in your backyard. You also can

*Taken with a normal lens, both the fore- ground subject and building in the back- ground are in sharp focus.*

*To make the bell stand out as the center of interest, a telephoto lens was used be- cause its depth of field is more limited and puts the building out of focus.*

take portraits or candid shots of people without having your camera right in their faces. Telephotos can, of course, make distant scenes appear closer and more dramatic.

You also can take advantage of a telephoto's characteristic changing of the normal perspective to make foreground and background subjects appear closer to each other than they really are. (Be sure to use a small f/stop to increase depth of field so both near and far subjects will be in sharp focus.)

*Wide-angle lenses,* on the other hand, tend to show foreground and background subjects with more distance between them than there actually is. So you can use a wide-angle when you want a background to be diminished in size. Since depth of field is greater with a wide-angle lens than normal or telephoto lenses, focusing is not as critical. However, it's more difficult to separate the subject from the background, because everything appears in focus in the picture, especially when you shoot with a medium or small f/stop. Be sure to use the depth of field scale on wide-angle lenses so you'll know and can control how much of the subject area will be in focus before you take the picture.

Wide-angle lenses are ideal not only when you want everything in the subject area in focus, but when you want to cover a wider field of view than is possible with a normal or telephoto lens. A wide-angle lens works well in close quarters,

*A wide-angle lens covers a wider subject area and has greater depth of field than a normal or telephoto lens; it was the best choice to sharply photograph the entire pool deck on this cruise ship.*

such as rooms or narrow streets, when you can't back away from your subject.

One thing you must always think about when using a wide-angle lens is distortion. In general, the wider its field of view, the more distortion a lens produces. For example, you can expect more distortion with a 21mm than a 35mm wide-angle lens. Some extreme wide-angle lenses, like those ranging from 6mm to 8mm, are called *fisheye lenses*. They have a field of view of about 180 degrees, usually produce a circular image on the film, and cause extensive distortion.

Whatever the focal length of a wide-angle lens, distortion is especially evident and bothersome when your camera is very close to the subject. For this reason, portraits taken with a wide-angle lens are never flattering. To fill up the frame with a person's head and shoulders, you must get close, and that distorts the subject's face because the nose is closer to the camera than the eyes and appears too big. Unless you like to make grotesque faces, avoid using a wide-angle lens for portraits.

*Subjects sometimes appear distorted when photographed with a wide-angle lens, depending how close you are and the angle you are shooting from.*

*Tilting up with a wide-angle lens causes distortion of vertical lines, which bend in toward the top of the picture.*

Distortion also occurs when you tilt a camera with a wide-angle lens up or down. Vertical lines appear bent rather than straight and parallel. If you tilt up, vertical lines and subjects bend inward at the top of your picture. Buildings, for instance, will look narrower at the top than at the bottom. When you tilt your camera down, a wide-angle lens will make vertical lines and subjects bend inward at the bottom of your picture. Fortunately you can see all this happening as you compose your picture in the viewfinder, so try to keep your camera level to avoid distortion (unless you like it as a special effect).

Of course, if you're into architectural photography, you'll certainly want buildings to appear undistorted in your pictures. The simple solution is buy a special and rather costly *perspective correction (PC) lens* that you can adjust to avoid the distortion which occurs with regular wide-angle lenses. Common focal lengths of PC lenses are 35mm and 28mm.

It can be very expensive to own a lot of wide-angle and telephoto lenses with different focal lengths, and it's cumbersome to carry them around. Fortunately, photographers have been blessed with a newer type—*zoom lenses*—that allow you to vary the focal length. They're great because you can increase or decrease the field of view, as well as the subject's image size, without changing lenses or moving your camera's position. This makes it easy to control composition. Just adjust the zoom until you see in the camera's viewfinder exactly what you want in the picture. And you won't miss any more pictures because

you were in the midst of switching from one lens to another. All you do is turn or push/pull the zoom control ring to change the lens focal length.

Unfortunately, one zoom lens can't cover the entire range of focal lengths for a 35mm camera. But you can buy them to cover various ranges—wide-angle (such as 24-35mm), telephoto (like 80-200mm), and minimum wide-angle to minimum telephoto (such as 35-70mm), which also includes the focal length of a normal lens.

*This lighted Christmas tree, on display in New York's Rockefeller Center, is a good subject for a time exposure.*

*The same tree creates an entirely different picture when photographed while zooming, which means changing the focal length of a zoom lens during the exposure.*

An extra benefit of zoom lenses is that they can be used creatively to give the feeling of motion to stationary subjects and also to produce interesting patterns and abstract images. This is referred to as zooming. As described in the first part of this book, you just change the zoom lens focal length while the camera shutter is open and the exposure is being made (see page 37).

Another type of lens that may make your photography more interesting is a *macro lens*. It allows you to take close-up pictures easily, and also serves in its primary role as a normal, telephoto, or zoom lens. You will hear macro lenses called by other names, including *micro lens* and *close-focus lens*. They're ideal

*A macro lens enables you to make close-up photos most easily, or you can attach a close-up lens to the regular lens on your camera. Both types allow you to focus closer than normally and make a larger image of your subject on the film.*

if you frequently like to make close-up pictures and don't want to bother with close-up lens attachments. The design of most camera lenses doesn't allow you to focus on subjects that are too close. With some normal lenses the closest you can get to a subject and keep it in sharp focus is 1½ feet. With telephoto or zoom lenses, the minimum focusing distance is even greater—sometimes 4 or 5 feet or more. However, if the lens is a macro type or has close-focus capabilities, you can get very near to the subject, usually within inches. This means your subject will be enlarged in size on the film, and often the detailed picture that results is quite impressive.

There are other types of lenses that you can use for close-up photography, although technically they are lens attachments rather than individual camera lenses. They're known simply as *close-up lenses*. You screw or snap them to the front of the lens that's on your camera. This means that close-up lenses can be used with many types of cameras, including some pocket and instant models, as well as 35mm cameras that have nonchangeable lenses. They magnify the image and allow you to focus closer to a subject.

*Take extra care composing pictures that are taken with macro or close-up lenses, especially if you're not using a single lens reflex (SLR) camera.*

When attached to a single lens reflex camera, a close-up lens is no trouble to focus. You just look in the viewfinder and turn the regular lens focusing ring until your subject looks sharp. With other cameras, when there is the main lens for the film and a separate lens for the viewfinder, you can't see the subject sharply focused. The problem is solved, with considerable inconvenience, by placing the camera a precise distance from the subject. You'll need a ruler to measure that distance, which is indicated in an instruction sheet that comes with the close-up lens.

Another problem with using close-up lenses on non-SLR cameras is composing your pictures. That's because at close range the viewfinder does not cover exactly what is seen by the camera lens for the film. Follow instructions for framing the subject that come with the close-up lens. There may be other guidelines for close-up photography in your camera manual.

Besides being made in various diameters to fit different sizes of camera lenses, close-up lenses come in several magnifying strengths. The specific magnification is referred to as the *lens diopter*. It's indicated by numbers +1 to

+10. The higher the number, the stronger the close-up lens. You can use them individually or put two together. Some are sold in kits of +1, +2, and +4 diopters, so you can combine a pair of them for other magnifications (for example, +2 and +4 = +6 power).

*Depth of field is very limited when you photograph with macro or close-up lenses, so you should focus on your subject carefully and use a small lens opening.*

    Remember depth of field? Well, it's very limited when you use close-up lenses. So try to use a small lens opening to increase depth of field as much as you can so more of your subject will be in focus. Since a small f/stop may require a longer shutter speed for the proper exposure, it's also a good idea to steady the camera by attaching it to a tripod. This also helps you keep the exact distance from your subject so that the focus remains sharp. You'll need plenty of patience to take effective close-ups, but chances are you'll be intrigued and pleased when you see the pictures.

## Filters and Other Lens Attachments

There are accessories you can attach to lenses that often will improve a photograph. Most common and useful are filters. They screw or clip on the front of a lens. When you buy filters, take your lenses to the camera store so you'll be certain they fit.

*Reflections on the window glass make it difficult to see the girl and her cat who are inside the house.*

*A polarizing filter attached to the camera lens was adjusted until it canceled out most of the reflection and made them more visible.*

A colorless filter that many photographers attach to each of their lenses is called an *ultraviolet (UV) filter*. It absorbs ultraviolet radiation that you can't see but that color films record. The radiation shows up as bluish haze in scenic shots, and a UV filter eliminates it.

What's more important is that the filter can be used as protection for your lens. Since it's clear and doesn't affect the picture except as described above, wise photographers leave UV filters on their lenses to guard the lens glass from dust, scratches, and other damage. Another name for the UV filter is a *haze filter*, but don't be misled—it does not eliminate any haze that you can see, just the ultraviolet radiation that the film would otherwise record.

A similar type of filter, but with an amber tint, is called a *skylight filter*. Besides filtering ultraviolet radiation, it reduces some of the bluishness that color films may record on overcast days and in the shade. Skylight filters are ideal for lens protection, too.

Skylight and UV filters have little effect on black-and-white films, but use them to protect your lenses. Since the filters are clear or almost colorless, they do not reduce the intensity of the light reaching your film, so there's no need to increase exposure.

Another popular type of filter, called a *polarizing filter,* does a number of good things. As mentioned earlier, it reduces reflections and glare, just as Polaroid sunglasses do. A polarizing filter also will reduce atmospheric haze and darken a blue sky. Another benefit is that it enriches the colors of your subject. And it does all these things for both color and black-and-white films.

The effect of a polarizing filter depends on its angle to the light source or reflection, and how much you turn the filter in its rotating ring. The effect is easy to see and control when you're looking through a single lens reflex camera. With other types of cameras, first hold the filter to your eye and rotate the filter ring until you see the effect you want, then put it on the camera lens in the identical position. Also remember that if you've been taking horizontal pictures and then want to take a vertical one, you'll have to readjust the polarizing filter.

A polarizing filter really makes your scenic pictures dramatic, especially because it cuts through atmospheric haze that is so prevalent wherever you go these days. And water scenes become more vivid, because reflections are reduced or canceled completely and colors are recorded more realistically. It's also amazing to see how a polarizing filter eliminates reflections on glass windows. Except with bare metal or mirrors, where it has no effect, use a polarizing filter whenever reflections or glare are bothersome.

One thing you must do is increase exposure when you use a polarizing filter. That's because it cuts down the intensity of the light reaching the film. Usually a SLR camera with an automatic exposure system or a built-in exposure meter will compensate for the filter and give the correct exposure. Otherwise you must increase the exposure according to the filter's instruction sheet, which usually advises opening the lens one to one and a half f/stops.

In those instructions, and the instructions that come with other types of filters, you'll come across a term that may be puzzling. It's *filter factor,* a number that tells you how much to increase exposure when a filter is used. For example, a filter factor of 2 means you must let in twice as much light—which is equivalent to opening up the lens one f/stop, or reducing the shutter speed to the next-slower speed. (Remember, most cameras with an automatic exposure system or a built-in meter that makes readings through the lens, as do SLR models, will compensate automatically and set the proper exposure when a filter is used; consult your camera manual for specific advice.)

Some filters are designed for color films, some for black-and-white films. There's probably little chance you'll use them, but you should know about *conversion filters* for color film.

Color films are made either for use in daylight or with indoor tungsten light (like normal household incandescent lamp bulbs—not fluorescent lights). If you take pictures with daylight film indoors under incandescent lights, they'll have an overall yellow-orange color and look unnatural. The solution is to use a blue-colored conversion filter, No. 80A, which prevents the off-color appearance.

*Colored filters change the tones of subjects shot with black-and-white film. Without a filter, the red leaves of this poinsettia plant photographed a dark gray.*

*When a red filter was placed over the camera lens, the leaves were recorded in a lighter tone.*

You can correct a tungsten color film the same way. Your pictures will have a bluish look if you shoot tungsten film outdoors in daylight instead of inside with incandescent lights. However, if you use a yellowish-orange filter, No. 85B, your outdoor pictures will appear in natural colors. A No. 85B filter requires an exposure increase of about two-thirds of a f/stop, while a No. 80A filter needs an increase of two f/stops; again, most SLR cameras make the increase automatically.

If you're like most photographers, you'll shoot daylight film for your outdoor pictures and then switch to tungsten film (or use flash) for indoor pictures without bothering with correction filters. (If you're in the middle of a roll, it can be removed in order to use the other type of film in your camera, and afterward the first roll can be reloaded.) Best of all, some of the newer color print films, like Kodacolor 400, give good color results in both outdoor and indoor light conditions.

Black-and white films record colors as shades of gray. For better pictures, you can use filters that will alter gray tones by making them lighter or darker. Filters for black-and-white films are colored—various shades of yellow, red, green, and blue—and they are identified by numbers. A popular filter to use is a No. 8 (medium yellow) that darkens the sky and makes your black-and-white

*A star, star-burst, or cross-screen filter placed over the camera lens makes bright light sources, like the sun, produce starlike effects. See another example on page 186.*

scenic pictures look more realistic. For a very dramatic effect, you can darken the sky even more by using a No. 15 (deep yellow) or No. 29 (deep red) filter. Of course, an increase in exposure is required. The amount depends on the color and density of the filter on your lens. A No. 8 (medium yellow) needs two-thirds of a f/stop more light, while a No. 29 (deep red) requires an increase of four f/stops. If you are more interested in black-and-white photography than in color photography, ask at your camera store for a handbook describing all the filters for black-and-white films, and suggestions for using them. For other effects, try the same filters with color films, especially landscapes and other scenic shots.

For color or black-and-white photography, there are other filters that create special effects. You can make bright spots of light, like the sun or light bulbs, appear starlike by using a filter that is known by several names—*star, starburst,* or *cross-screen filter.* Etched lines in the filter break up the light into four rays (or eight rays if you put two filters together). Turn the filter until the rays point in the direction you like best. Photograph the sun glittering off water with this filter and you'll get a picture of many tiny stars.

Several images of the same subject will appear in your photo when you attach a *multiple-image* or *repeating lens.* You have a choice of those optical filters to make three, five, or six identical images. The images will appear in

*A multiple-image or re-peating lens attached to the camera will make additional images of your subject, as it did with this single rose. Use a large lens opening and contrasting background for the best results.*

circular, pyramid, or parallel patterns, depending on the filter style you choose. Like the star filter, these special-effects attachments are only for occasional use—some subjects don't turn out very well with such filters, and the result may be just gimmick pictures instead of worthwhile photos.

For portraits, you should have some success with a *soft-focus filter* that will soften the features of your subjects. The effect is more appropriate for women than men. Soft-focus filters also add a misty effect to scenic shots, and sometimes give them more appeal. The vividness of colors in your pictures also will be reduced by a soft-focus filter. To make your own soft-focus filter, stretch a piece of dark nylon hose over the lens. Or spread a thin layer of Vaseline over a piece of glass or UV filter that's in front of your lens (not the lens itself). The effect varies according to how the petroleum jelly is applied. For instance, you can leave a clear area in the center of the glass or filter so only the edges of your picture will be diffused. Afterward, remove the Vaseline with lens cleaner and lens cleaning tissue (see page 76).

Besides filters, there are some more lens attachments that may be helpful in your quest for better pictures. They go *between* the lens and camera body, and are for 35mm single lens reflex cameras. Their common purpose is to help you get bigger images on the film.

One such attachment increases the focal length of the lens on your camera. It's called a *lens extender, tele-extender,* or *lens converter.* This optical attachment turns your normal lens into a telephoto or makes a telephoto lens more powerful. Lens extenders are of two types—a 2X, which doubles lens focal

*For this soft focus photo, Vaseline was spread lightly on a UV filter, leaving a clear circle in the center so the subject's face would still be sharp. (Afterward the petroleum jelly was removed with liquid lens cleaner.)*

length, and a 3X, which triples it. If you put a 2X extender on a 50mm normal lens, for example, it becomes 100mm. A 3X extender on a 50mm lens makes it a 150mm.

A lens extender is less expensive than buying a telephoto lens, but the images made with the extender may not be as sharp. Another drawback is that an extender requires an increase in exposure—two f/stops for a 2X extender, three f/stops for a 3X. For occasional use, lens extenders are okay. An advantage is that you can attach them to lenses of various focal lengths, including zoom lenses. Make sure the extender you buy is the correct one for your particular camera so that the internal mechanisms of your main lenses still work. Otherwise your camera's automatic exposure or metering system might not function properly.

Other lens attachments are designed for close-up photography. These are nonoptical *extension tubes* or *extension bellows* that are inserted between the main lens and the camera body. They allow you to focus closer to your subject and thus make a bigger image on the film. The rigid tubes (sometimes called rings) come in various widths. You can add or remove them depending on the amount of magnification you want. The flexible bellows is adjustable and thus

*You can make extreme close-ups of a subject with a 35mm SLR camera by attaching an extension bellows between the camera and the lens. Here a full-frame image is being made of a flower's stamen. A tripod and cable release are used to prevent camera movement and a blurred image.*

more versatile, because it's easier to change the magnification of your subject. Depth of field is very limited when you use extension tubes or bellows, so you must focus on your subject very carefully. Also, an increase in exposure is required, depending on how far the main lens is extended from the film. Actually a macro lens is less cumbersome and easier to use for close-ups than fiddling with extension tubes or bellows. However, if you ever want to make extreme close-ups, which are larger than life size on the film, only an extension bellows or tubes will make such great magnification possible.

# 4.

# Flash Use

## *Types of Flash*

Nobody was happy using flash in the old days. A couple of decades ago, flashbulbs were big and awkward to carry. They could burn your fingers and were a bother to dispose of after they were fired. Worst of all, you had to consult a chart on the flashbulb carton or the film instruction sheet to figure out the correct exposure to use. Fortunately, flash has come of age. A tiny gas-

*Flash is a portable and powerful source of light, as shown by this flash picture of a majestic lion taken indoors through the bars of his cage in a zoo.*

filled tube, triggered by an electrical charge, now produces the quick burst of bright light that's needed for flash pictures. Flash units are small and convenient; some cameras even have them built in. Best of all, many of them figure flash exposures automatically. These days flash is easy and fun to use.

Because of the versatility of modern flash units, you'll find more to do with flash than just using it to take pictures indoors. Flash is a big help outside in daytime to fill in any shadows on your subject. It is valuable in close-up work because its bright light lets you use small lens openings for better depth of field. Flash also stops the action of quick-moving subjects, like babies and pets. At night, off the camera, it can be fired several times to light up a large area. And flash can be bounced off a ceiling or wall to improve interior shots being exposed by natural light.

Just go in any camera shop and you'll see a great variety of flash units. We give here a summary of the different types so you'll know what's best for you. First, today's photographers have two major choices—electronic flash units, or flashbulbs mounted in convenient clusters. Electronic flash is the front-runner because it gives thousands of no-fuss flashes, and at much less cost. Flashbulbs—whether packaged as flashcubes, magicubes, flipflashes, or flashbars—have to be replaced after their four, eight, or ten flashes have been fired.

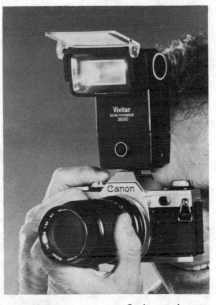

*This instant camera has an automatic built-in electronic flash that turns on when you slide the flash reflector to one side.*

*An accessory automatic flash attaches to the top of this 35mm camera by slipping the unit into the camera's hot shoe. It makes direct electrical contact so a connecting cord is not required to fire the flash.*

Flashbulbs are most often used on older instant and Instamatic-type cameras.

The majority of new instant, pocket, and small 35mm models either have *electronic flash* built into the camera body or have a separate electronic flash unit available as an accessory. Most of these give automatic flash exposures.

For the built-in flash models, you pop up, pull out, or turn on the flash, and the exposure is set automatically when you press the shutter release. The sensor or through-the-lens meter for the camera's automatic exposure system reads the flash light reflected from your subject and controls the *flash duration* to give the correct exposure.

On accessory automatic flash models that must be attached or plugged into the camera, the sensor that reads the light and controls the flash duration is on the flash unit itself. However, some cameras with automatic exposure systems will calibrate and control exposure for an accessory flash if that *dedicated flash unit* is designed specifically for the camera you're using.

The flash's *minimum-maximum operating range* is the most important thing to know when you use a flash (built-in or an accessory type) that has automatic exposure control. In other words, how close and how far away can your subjects be in order for the auto-flash to make correct exposures? The range depends on the particular flash unit. Some have rather limited range, like 3½ to 12 feet; others have a greater range, such as 2 to 40 feet. If your subject is closer than the minimum distance, the picture will be overexposed; if it's farther than the maximum distance, the picture will be underexposed. Read and memorize the auto-flash operating range in your flash manual or camera instruction booklet.

If your camera has adjustable lens openings, you must consult the flash unit's *calculator dial* and preset the f/stop that's indicated for correct flash

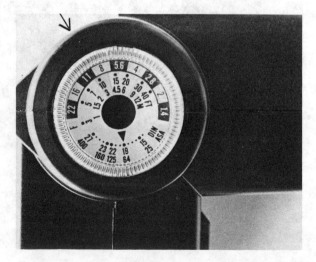

*To figure exposure for an electronic flash that is not automatic, first set the unit's exposure calculator dial to the speed of the film in your camera; here it is ASA 64. After determining the distance the flash is from your subject, find that distance on the dial and look opposite to determine the f/stop to set on the camera lens. As an example, if the flash-to-subject distance is 10 feet, the correct lens opening would be midway between f/8 and f/11 (arrow).*

exposures. The exact f/stop depends on the speed of the film you are using; set the film's ASA number on the flash calculator dial first.

The other type of electronic flash unit—with manual exposure control—is less expensive and less practical than the automatic-exposure models. The reason is that you have to spend time calculating and setting the exposure for each flash picture. (It's not that much of a problem, but you're probably better off concentrating on the composition of your picture rather than on figuring exposures.)

For a flash with manual exposure control, use the calculator dial or chart on the flash unit to determine the f/stop to set on your lens. First calibrate the dial by adjusting it for the speed (ASA) of the film you are using. Then, whenever you are going to take a flash picture, determine how far the flash unit is from your subject, locate that distance on the flash calculator, and look opposite that number to find the f/stop to use for the correct exposure. Study the accompanying illustration. The easiest way to determine the flash-to-subject distance, if the flash is mounted on your camera, is to focus on your subject and then look at the lens focusing scale for the distance indicated in feet or meters.

*If the shutter speed is too fast on a 35mm single reflex camera, the shutter will not be open fully when the flash goes off and part of the picture will be blocked, as happened here. Usually a SLR camera's shutter must be set not faster than 1/60 or 1/125 second for proper flash synchronization.*

You're probably aware that no mention has been made of shutter speed when electronic flash exposure is discussed. That's because the exposure time, which shutter speed normally controls, really depends on the duration of the light from the flash. Electronic units give flashes of very brief duration, usually no more than 1/1000th second. With electronic units featuring automatic exposure, which control exposure by varying the flash duration, the light may even be as brief as 1/50,000 second. That may be hard to imagine, but this *is* the electronic age.

The shutter speed does matter, however, when you're using a single lens reflex camera. As you may remember, it has a focal plane shutter—a curtain that opens and closes across the face of the film. It must be completely open when the flash goes off, or only a portion of the film frame will be exposed. That means the fastest shutter speed you can use for proper *flash synchronization* with SLR cameras is usually 1/125 or 1/60 second (your trusty camera manual will tell you). Slower speeds can be used, but other light besides the flash may also have time to register on the film and illuminate subjects in your picture (with good or bad results, depending on the image you were after). With some of the newer camera models, the moment you connect an electronic flash or turn on a built-in flash unit the camera automatically sets the

*Flash pictures with some camera models require you to use flash bulbs instead of an electronic flash unit. This pocket camera is designed for flipflash, a throw-away reflector with eight tiny flash bulbs.*

shutter speed for proper flash synchronization.

In non-SLR cameras, the shutter design is different, usually the overlapping-leaf type, and you can use any shutter speed with electronic flash; flash synchronization is not a concern.

Some cameras still require *flashbulbs* to be used for flash pictures. On simple models, when you insert the flashcube, magicube, flipflash, or flashbar, the camera automatically adjusts the shutter speed and/or lens opening to give the correct flash exposure. Warning: Read your camera booklet to learn the minimum and maximum distance your subjects can be from the camera for flash pictures. Otherwise you're certain to get lots of overexposures and underexposures.

You also can buy single flashbulbs to insert in reflectors that attach to some cameras, usually older models. The exposure you need to use depends on the size of the reflector, the size of the flashbulb, the speed of the film you are using, and the distance of your subject. You have to set shutter speed, as well as lens opening, because the flashbulb's duration is at least 1/50 second—much longer than the duration of electronic flash.

If the flash reflector is connected to the camera by a cord, synchronization is a concern because the flashbulb must go off and build to its peak brightness before the shutter is open. Sometimes there is a special synchronization socket or switch on the camera that's marked with a FP or M for flashbulb use. (When a synchronization choice is offered on the camera, the socket or switch position marked X is the one to use with electronic flash units.)

Considering the various types—flashbulb or electronic, and electronic with manual or automatic exposure—what's the best flash unit for you? The most versatile is an accessory electronic flash unit with automatic exposure that can be attached to the camera. Most convenient of this type is one that's designed especially for your camera model and uses the camera's automatic exposure system to control the flash exposures. For simple cameras, a built-in electronic flash is the best choice, because it's always ready to use and usually adequate for casual flash photography.

## Flash Features

Now that you're more familiar with the various types of flash, let's consider their basic and special features that can affect your flash photography. First, it's wise to read an electronic flash unit's instruction booklet, because it has a page of technical data that will help you tell whether the unit will suit your purposes. Key things to look for (and compare with other units) are the type of batteries it uses, the number of flashes it gives, and the time it takes to recycle between flashes. All these are interrelated. The power of a unit's light output also is important.

*Flash can be used effectively outdoors as well as inside. To highlight the details of this flower and make it stand out from the background, the exposure was made with light from an electronic flash instead of the daylight.*

Flash units are designed for *alkaline* or *nickel-cadmium batteries* (known as *ni-cads*) or both. Alkaline batteries are the type you replace when they're exhausted. Ni-cads can be recharged, which is a moneysaver. Alkaline batteries give more flashes per set than ni-cads do per charge. For example, units using four AA-size batteries vary in number of flashes from 75 to 250 for alkaline and 50 to 80 for ni-cads. Of course, afterward you have to throw the alkalines away, while the ni-cads can be recharged and used again and again. The initial cost of ni-cad batteries or power pack and the recharger (made by the flash manufacturer and also General Electric and other companies) is higher than that of the replaceable alkaline batteries, but the ni-cads should save you money in the long run. One reason is that alkaline batteries must be replaced even when you don't use them, because they lose their power over a period of time.

Also, the more exhausted the batteries, the longer it takes for the unit to recycle and be ready for the next flash. After each flash, batteries must refill an electrical capacitor with enough energy to produce the flash unit's full light output, and this is known as the *recycle time.* Check the recycle time given in the flash unit's technical data, but remember that it's based on fresh or fully charged batteries. Depending on the unit, recycle time can range from 4 to 14 seconds, and much longer as the batteries wear down. Obviously, the faster the recycle time, the sooner you can take another flash picture—and that's important when your subjects' actions or expressions are changing quickly.

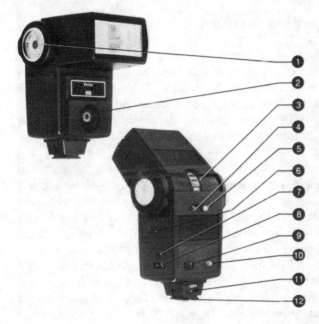

*Many of the popular features of an electronic flash are found on this versatile model. 1) Illuminated calculator dial; 2) Light sensor; 3) Angle scale for tilting head; 4) Automatic exposure signal/Sufficient light indicator; 5) Calculator dial light button; 6) Battery compartment; 7) Socket for camera/flash connecting cord; 8) Receptacle for AC adapter plug; 9) On-off switch; 10) Ready light/Open flash button; 11) Lock lever for mounting foot; 12) Mounting foot with hot shoe contacts.*

When an electronic flash unit is recycled and all set to fire again, a tiny *ready light* glows on the back of the unit to signal you that it's okay to take another flash picture. If you shoot before the light goes on, the flash may go off but its light output will be less than it should be and the picture will be underexposed.

Especially nice are the built-in flash units and some other automatic models designed for specific cameras that signal you with a light in the camera's viewfinder when the flash is recycled and ready to fire again. That way you don't have to take your eye away from the camera or the action to check a ready light on the back of the flash unit. Some units also have an audible signal that serves the same purpose.

Also be sure to check the flash technical data to learn and compare the *light output* of electronic flash units. Often it's given as a number and called BCPS (beam-candlepower-seconds). BCPS numbers range from 350 to 8000. The higher the BCPS, the greater the light output. And, of course, the greater the light output, the greater the range of the flash. It also means you can use a smaller f/stop for correct flash exposures, and that's good if you're after better depth of field.

Sometimes in the technical data for a flash unit you'll see a *flash guide number* listed for ASA 25, ASA 100, or another speed of film. You can use this flash guide number as another way to compare the light output of various flash units: The higher the guide number, the greater the light output.

Be wary, however, because flash manufacturers decide a unit's guide number, and sometimes they exaggerate in hopes of increasing sales by letting you think the unit is more powerful than it really is. If your flash pictures are

underexposed, you may be the victim of a jacked-up guide number. Try a lower one.

Some of the more expensive electronic flash units with automatic exposure have extra features. For instance, instead of just one minimum-maximum operating range, it may offer two or three, which means you have a choice of lens openings. If you select a close maximum range for automatic exposures, you can use a smaller f/stop and thus get increased depth of field. If you need a distant maximum range, a wider f/stop is required, which reduces depth of field.

Some units have *power-saving thyristor circuitry*. When subjects are close to the flash, less light is needed to illuminate them, so the full flash power is not used. If the unit has this special circuitry, the unused power returns to the capacitor, which shortens recycle time. This also means batteries last longer and more flashes are possible before they must be replaced or recharged.

Another valuable feature on advanced auto-exposure flash units is an *automatic exposure signal*. It's a light that glows momentarily to tell you that light from the flash was sufficient to make a correct exposure. If it doesn't glow, the flash was too weak and your subject will be underexposed. This can be used for an exposure test before a picture is actually taken. The unit usually has an *open flash button* that will fire the flash without making it necessary to press the shutter release. That way you can check to see if the automatic exposure signal glows and thus avoid wasting film. This is especially valuable when you're taking bounce flash pictures and the light is not aimed directly at your subject.

A few other convenient features on some flash units include a flash head that swivels or tilts at various angles to make control of bounce flash pictures easier. Another is a *zoom flash head* that varies the concentration of the light,

*This sophisticated automatic electronic flash unit features a zoom head that varies the light for normal, telephoto, or wide-angle lenses (with a flip-down filter to spread the light for lenses as wide as 28mm), as well as an adjustable tilting head for bounce flash pictures.*

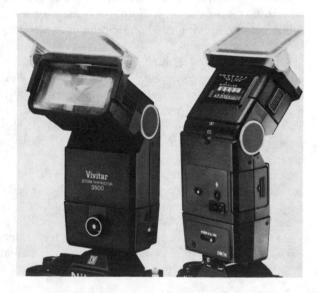

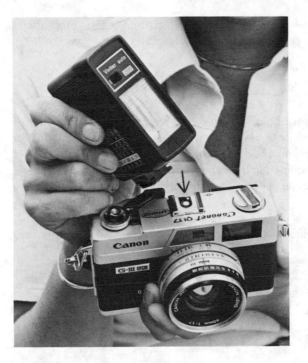

*A connecting cord be-tween the camera and flash is not required when the camera fea-tures a hot shoe (arrow) for mounting the flash unit.*

depending on whether you are using a telephoto, normal, or wide-angle lens. Other models have wide-angle and/or telephoto attachments for the flash head to spread or concentrate the light for the type of lens you are using. Be sure you know the flash unit's basic *angle of illumination.* This should be given in the technical data in the flash instruction booklet. Usually it tells you the focal length of the widest wide-angle lens that will be covered by the flash, like 35mm or 28mm. If you use the flash with a lens that has a field of view that's too wide, the edges of your picture will be dark.

Before discussing the ways to use flash, you should know about camera and flash connections. The most common way to attach an electronic flash unit to a camera is to slip it in the *hot shoe* that's on top of the camera. Normally you won't need a connecting cord to fire the flash when the camera's shutter release is pressed, because the hot shoe and base of the flash make direct electrical contact. Although it's convenient to have the flash mounted on the camera, many times you'll want to remove it for more creative lighting effects. Then you'll need a flash connecting cord between the flash and the camera. It's plugged into the camera's flash cord socket. If there are two sockets, connect the cord to the one marked X, which is the symbol for electronic flash. (The other socket is for flashbulbs.) If your camera doesn't have a flash cord socket, buy a hot shoe adapter that has a socket you can plug the cord into.

Large or heavy flash units can be attached to the camera with a flash bracket

that screws into the camera's tripod socket. The bracket places the flash above and off to one side of the camera lens, and a connecting cord is required.

## Flash Techniques

One reason for mounting (or holding) any flash above and off to one side of the camera is that the shadows it makes from that angle give more dimension to your subject. This sculptural effect is often called *modeling*. When a flash is built into the camera or mounted in the camera's hot shoe, the effect it gives is called *flat lighting*. Your subject is well enough illuminated, but it lacks a three-dimensional look.

*Off-camera flash* is one of various techniques you should try with your flash (of course you're out of luck if the flash is built into your camera). It's very

*Off-camera flash allows you to try a greater variety of lighting effects; use a coiled connecting cord because it is less apt to get tangled.*

*Flash aimed directly at your subject from the camera sometimes is harsh and uneven.*

*Often a picture illuminated by bounce flash is more pleasant and uniformly exposed (see text).*

effective when making portraits with flash, because it gives shadow and depth to a person's face instead of the usual flat, frontal lighting. When using flash off the camera, pay attention to where you place or aim it. If you hold the flash below your subject's face, it gives the person an evil look. To make a silhouette, the flash is placed behind the subject and flashed at a light-colored wall or backdrop.

Direct flash on a subject is often too harsh, so try *bounce flash* for softer illumination. You aim the flash at a white or light-colored ceiling or wall so the light reflects onto your subject. It doesn't work very well if the ceiling or wall is too far from your flash or subject because the light may not be strong enough to travel that far. Bounce flash is a good technique when your subjects are in front of a window or mirror, because it prevents annoying reflections of direct flash light. Glass objects, or objects behind glass, also can be photographed without reflections with bounce flash. In many situations it gives a much more natural lighting effect than direct flash. Bounce flash must be aimed carefully so it does not fall short of the subject or go behind it.

How do you figure exposure with bounce flash? Cameras with automatic exposure systems should produce correctly exposed pictures. And if the flash itself features auto-exposure and a tilting flash head, exposures with bounce flash should also be okay (watch the unit's automatic exposure signal to see if the light was sufficient). However, an exposure problem occurs if you take an auto-flash unit off the camera and point it at a ceiling or wall—the sensor on the front of the unit cannot read the flash light being reflected back to the camera. Some auto-flash units have a removable sensor that can be mounted in the hot shoe so it will still be at the camera position to read the flash light and give automatic correct exposures. A cord connects the sensor to the flash.

To figure bounce-light exposures when using a manual electronic flash, you must measure the distance the light travels from the unit to the reflecting surface to the subject. Next, consult the calculator dial to find the correct lens opening for that distance, then open the lens *wider* by one or two f/stops. That's because the ceiling or wall absorbs and scatters some of the flash light, so the illumination is not as strong when it reaches the subject compared to a flash aimed directly at the subject that covered the same total distance.

Another technique that's rewarding is *open flash*. It's ideal when your subject is too far away to flash from the camera position or too large to illuminate with a single flash. The flash is removed from the camera and fired independently by pressing the unit's open flash button.

Put your camera on a tripod, set the shutter speed to B for a time exposure, and attach a cable release with a lock that will keep the shutter open. Before you open the shutter, figure how far you're going to hold the flash from your subject. Then set the lens opening according to the f/stop indicated on the flash calculator dial for the flash-to-subject distance.

Now open the shutter, move closer to the subject and fire the flash, and then

*This house was photographed at night with the open flash technique. The shutter was held open (on B, with a cable release) while the flash was fired five times from different locations: from the left and right outside of camera range, in the center from behind a bush on the lawn, and from left and right on the porch while hiding behind the wall. The lens was covered with a piece of black paper to avoid extraneous light each time the photographer moved from one flash position to another.*

go back to the camera to close the shutter. Or get a friend to help you. Obviously, any natural or other existing light will also record on the film while the shutter is open, so the scene should be dark or at least very dim. And be careful you don't stand between the camera and the flash or your silhouette may show up in the picture. Kneel down, stand to one side, or hide behind an object in the scene.

Large subjects, like the exterior of your home or the interior of a room, require several flashes for adequate illumination. Aim at a different area of the subject each time you flash, trying not to overlap the flashes. Also keep the same distance from the subject each time you flash so the areas will be illuminated evenly. It's fun to experiment with open flash, because the results can be surprising and very effective.

One of the best times to consider using flash is when you're taking pictures outdoors in daylight. The purpose is to reduce shadows on your subject with *fill-in flash*. This will improve your pictures tremendously, especially photos of people. There are two light sources, the sun and the flash—so what about exposure? Since you're just using the flash to "fill in," set your camera for the regular daylight exposure meter reading. (Caution to SLR owners: For proper

*These beauty contestants were photographed at midday and the overhead sun shadowed their faces.*

*Fill-in flash illuminated the shadows and made the girls and the picture much more appealing.*

flash synchronization, remember that your shutter speed can be no faster than 1/60 or 1/125 second, as your camera instructions indicate.) When the lens opening has been set, check what the f/stop is and find that number on the flash calculator dial. Then look opposite on the distance scale and you'll see how far the flash must be placed from your subject for good fill-in light.

If the flash is too close, it will overpower the natural light and "wash out" your subject. If the flash is too far away, it won't have any effect. To get a flash closer to or farther from the subject, change your camera position. For best composition after you change position, you may have to switch to a lens with a different focal length (a zoom lens is very helpful in this regard). If that's not possible, keep your position but use a flash connecting cord to place the flash closer or farther away. If the cord's too short, you can buy longer extensions. An alternate solution when the flash should be farther away from the subject is to cut down the amount of light by covering the flash head with a layer of clean white handkerchief. Each layer reduces the flash light about one f/stop. Use the flash calculator dial to figure out how many f/stops difference (and thus how many handkerchief layers) are needed to compensate for the close distance you are to the subject. Even easier to use are some of the better electronic flash units that have a *variable power control* which you can adjust to provide the appropriate amount of fill-in light with your flash. Finally, be aware that many cameras with built-in or camera-controlled auto-flash automatically control flash brightness for the correct amount of fill-in light. Check your camera's instruction booklet for details.

## Flash Problems

Let's face it: a lot of flash pictures are disappointing. Usually it's because the photographer isn't familiar with the flash unit or hasn't thought about the best way to aim the flash. Here are some common flash problems that occur with various types of cameras and flash units, and some methods for avoiding them.

Remember that flash exposure depends on the distance of the flash to the subject. There's going to be trouble if one of your subjects is closer to your flash than another, because they will be exposed unevenly. If you figure the exposure for the closer subject (which is what an auto-flash unit will also do for you), the subject at a greater distance will be underexposed and too dark. If you figure exposure for the distant subject, the subject closer to you will be overexposed and washed out.

You can compromise by setting the exposure for a distance in between the two subjects, but neither will have just the right exposure. A better solution is to use bounce flash for both subjects. If this is not possible, then change your camera and flash position, or move your subjects, so they are both the same

*Two flash problems are evident in this picture. First, the off-camera flash unit was carelessly aimed to the left, and the people on the right were not illuminated. Also, its sensor automatically exposed for the lady in the foreground, causing the people in the background to be underexposed.*

distance from the flash. Keep this in mind when you are taking pictures of groups or interiors with flash.

Uneven flash lighting sometimes occurs when your flash is not pointed at the subject. This usually happens when you are holding the flash unit after taking it off the camera and aren't careful about aiming it. Just before you shoot, glance at the flash unit to be sure it's pointing in the direction you wish. If you're having a friend hold and aim the flash unit, make the same check.

Shadows in the background can be a serious distraction in flash pictures. If you're not paying attention, a black outline of your subject can be cast on the wall behind. Avoid this by moving your subject away from the background so that any shadows will be lost in the darkness behind the subject, or by bouncing the flash off the ceiling. If you can't move your subject away from the wall or other light-colored background, make sure the flash is mounted or held directly over the camera lens. That way any distracting shadows from the flash will fall directly behind the subject and not be recorded on the film. Of course, if you turn the camera vertically, you'll need to reposition the flash directly above the lens. If the flash unit is mounted in your camera's hot shoe, use a flash connecting cord so the flash position can be changed. If your flash is built in and you want to take a vertical shot, be sure to turn the camera so the flash is above the lens, not below it (otherwise ugly shadows will rise above your subjects instead of disappearing behind them).

*To avoid annoying flash shadows, like these on the subject's shirt and above his head, make sure the flash is positioned above the lens instead of below it; this problem most often happens to careless photographers who have the flash built into their cameras.*

Before you take a flash picture, look at the background for shiny surfaces or objects that may cause a bright reflection. Windows and mirrors are the worst problems. Polished wood paneling or furniture and enamel-painted walls throw back annoying reflections, too. Move your subjects away from those shiny surfaces, or place your flash so the angle of reflected light will not return into the camera's lens. Bounce flash often is a good way to avoid reflections.

Ever have people in your color flash pictures appear with bright red or pink eyes? You've actually photographed the inside of their eyes as the flash reflects off the retina. Avoid this red-eye rabbit look by holding the flash a few inches to a foot higher than the camera lens so the angle of the flash reflection changes and doesn't come back to the camera. If red-eye is a persistent problem, buy a special *flash extender* in order to raise a camera-mounted electronic flash unit or flashcubes or magicubes.

By the way, never count down or tell people when you're going to take their flash picture. Many times they anticipate the bright light and close their eyes.

*When taking a picture with flash toward a mirror or other reflective surface, shoot at an angle so the bright light will not shine back into the camera lens and ruin the photo.*

And no one likes pictures of people who look asleep. Sometimes a subject tells you he blinked. Ask if he saw a pink light or a white light. If it was pink, he saw the flash light through closed eyelids, so you'd better take another shot.

A flash extender also helps avoid reflections when your subjects wear eyeglasses. If the flash is built into the camera, and a person wearing glasses is looking directly into the lens, have him tilt his head down slightly so the flash reflection will be angled below the camera lens. Otherwise, keep the flash higher than the camera to prevent eyeglass reflections from entering the lens.

Your flash pictures will get better with practice. Flat, frontal lighting that results when the flash is mounted in the camera's hot shoe provides good illumination, but be sure to try other techniques like bounce flash and fill-in flash.

Frequently film is wasted because the flash just didn't go off. Dirty contacts often are the enemy. Battery ends and connections may be corroded. Usually

*For well-illuminated pictures with auto-exposure flash, it's important to know your flash unit's minimum-maximum operating range so your flash photos won't be overexposed or underexposed.*

it's not the greenish goo you're used to seeing when batteries leak, but a thin invisible chemical film that builds up. Wipe the battery and flash unit contacts with a clean dry cloth (never with your fingers). If they're hard to reach, use the eraser on the end of a pencil. Also check and clean the contacts on the camera hot shoe and flash base, or the connecting cord plugs and the camera flash sockets. Sometimes the connecting cord is broken internally; short-circuit the cord's camera-connection plug by touching its electrical contacts with a paper clip to see if the flash goes off. Or maybe the flash didn't fire because the plug pulled out of the camera socket (or you forgot to connect it in the first place). Sometimes the reason for flash failure is very simple—the batteries are exhausted, or you didn't remember to turn the unit on.

With auto-exposure units, make sure that your fingers or camera case or something else doesn't block the sensor and cause overexposures. Also with auto-exposure flash, be sure your subjects are within the flash's minimum-maximum operating range or they'll be overexposed (if the flash is too close) or underexposed (if they're too far away).

Several other exposure problems can occur with flash units featuring automatic exposure. Avoid objects between the flash and main subject that can fool the flash by reflecting light back to the sensor before it reaches your subject. You'll have a nice flash picture of the foreground object, but your subject will

be underexposed. Move the object or change your camera angle to eliminate it.

Also be careful of very light-colored or very dark backgrounds. If your subject is small and the background is dark, such as outdoors at night, there's not much to reflect the flash back to the sensor, so the automatic unit mistakenly increases the flash duration and causes your subject to be overexposed. When the background is very light, it reflects too much flash light back to the sensor, which causes a flash duration that's too brief to illuminate your subject, and underexposure is the result. In such situations, the best solution is to switch the unit from automatic to manual and set the exposure yourself.

Also remember to wait until the electronic flash unit has recycled to full power (watch the ready light), or else the flash picture probably will be underexposed. Finally, if you're taking flash pictures outdoors in winter weather, be aware that batteries lose power when cold, so recycle time will take longer—unless you keep the flash unit warm under your coat until you're ready to use it. Do the same with your camera if it has built-in flash.

Since electronic flash is quite inexpensive to fire, you can practice the various flash techniques so you'll know exactly how to use your flash to get better pictures.

# 5.

# Film Selection

## Types of Film

Of course you need film to take pictures, but what type is best? The choice may be simple, or something you have to think about, depending on your camera. If you have a Kodak instant camera, it uses only one of two films—Kodak's PR-10 or Kodamatic color print film. Likewise, if you shoot with a Polaroid SX-70 instant camera, there's only a single film available, SX-70 color print film. For Polaroid's newer 600 series instant cameras, you must use Polaroid 600 film. Photographers using pocket or Instamatic cameras have a wider choice of films, and for 35mm camera users there's an even greater selection.

Although Kodak makes most of the film sold in the United States, you can buy several other brands. These include Ilford, Agfa, and Fuji, and some "off" brands that are made for specific retail stores, like K-Mart's Focal films and Sears' Color films. Pictures from each brand and type of film, especially color, have a certain look to them, so you'll really have to shoot several kinds to decide which film pleases you most. (Of course, the processor who develops and prints your films can make a difference in how the pictures look, too.)

Whatever kind of film you're buying, it has to come in the correct container and be the right size to fit your camera. Pocket and Instamatic cameras use *cartridge film,* which comes in a plastic cartridge that's especially easy to load in the camera. Just open the camera back, insert the cartridge, close the back, and advance the film until it automatically stops in position for the first exposure. When all the film has been exposed, you just remove the cartridge and send it to a processor.

Film for 35mm cameras comes in a metal *cassette* (Kodak calls it a *maga-zine)* which has a short length of film extending from the container. You open

*To fit in different types of cameras, films come in a variety of containers, including (left to right) packs, rolls, cassettes, and cartridges.*

the camera back, insert the cassette, and attach the "leader" of film to a take-up spool in the camera. Then you close the camera back and advance the film until a 1 shows on the film frame counter to indicate you're ready for the first exposure. When the film is all exposed and ready for processing, it must be rewound into the cassette before the camera back is opened.

Some cameras, usually older models or large cameras, use *roll film*. It comes on a spool wrapped in a paper backing that protects the film from light. You open the camera back, insert the spool and attach the tongue of the paper backing to a take-up spool. Then you close the back and advance the film until frame number 1 is in position. When the roll is all exposed, it is wound entirely onto the take-up spool before opening the camera back. Then it's removed and sent to the processor.

Instant cameras use a *film pack*. Sheets of film are in a plastic or metal pack with a light-tight cover. After you place the pack in the camera and close the camera back, you eject or pull out the cover sheet so the first piece of film is ready to be exposed. When all the instant pictures have been made, the empty pack is removed and replaced with a new one.

Besides coming in different containers, films have different *sizes*—identified by numbers—for different types of cameras. Pocket cameras use small 110-size cartridge film. Instamatic cameras require larger 126-size cartridge film. Film in cassettes for 35mm cameras is identified as 135-size film, and more commonly just called 35mm film because its width measures 35 millimeters. Roll films come in a variety of sizes, including 120, 127, and 620. As you read earlier, film packs for instant cameras depend on the specific model—PR-10 or Kodamatic for Kodak instant cameras, SX-70 or 600 for Polaroid's popular instant models. (Other Polaroid instant cameras, including the Colorpack series, use instant

*Films are made in a number of different types, sizes, speeds, and exposures. Look at their packages carefully to make sure you're buying the one that fits your camera and purposes.*

films with different identity numbers.)

Now that you know about various film containers and sizes, how many pictures can you shoot? The *number of exposures* varies. Polaroid's SX-70 and 600 instant film packs and Kodak's PR-10 and Kodamatic instant film packs offer no choice—10 pictures each. Cartridge films for pocket and Instamatic cameras come in 12- and 20-exposure lengths. The number of exposures for roll films ranges from 8 to 24, depending on the camera's picture format (square or rectangular) and the length of the roll.

Film cassettes for 35mm cameras offer a wide variety in exposures—12, 20, 24, 36 or 72, but not all films come in all those different lengths. Most economical are film cassettes with 36 exposures, because the cost of film and processing is less per print or slide than with 12-, 20-, and 24-exposure films (only black-and-white film is supplied in 72-exposure cassettes).

Additionally you can buy *"long" rolls* (50 feet or more) of some 35mm films and load cassettes with different lengths yourself. This is done easily enough with a *bulk film loader* (ask for a demonstration at your camera store). Although long rolls are more economical than buying cassettes with specific lengths of 35mm film, most often they are used by photographers who develop their own film instead of sending it out for processing.

After learning the correct film size and deciding the length to use in your camera, you'll need to choose a basic type of film—black-and-white or color. If you go with color, you have a choice of *color print film* or *color slide film*. Like black-and-white films, the first color type produces a negative image from which prints are made. The second type, color slide film, produces a direct positive image that is best seen when projected on a screen. Sometimes this type is called *color transparency film*.

*Color print films produce negatives for making prints, while color slide films produce transparencies for projection. However, you also can have color prints made from slides, and slides made from color negatives.*

Always choose a color film that is designed for the kind of finished pictures you want—prints or slides. When you're buying film, an easy way to know its type is to check the film's name. If it includes "chrome," like Kodachrome, it's a color slide film. If the name includes "color," like Kodacolor, it's a color print film. Of course, the film box also will tell you whether the film is designed to make slides or prints.

What if you want both types of results? Good news—color prints can be made from color slides, and color slides can be made from color print negatives. For the best quality, however, shoot with a color print film when you want prints and a color slide film when you want slides for projection.

What else should you consider when selecting a film? If you're going to shoot with color slide film, you have to select the kind that's designed for the light conditions. While negative films, both color and black-and-white, give acceptable results indoors and outdoors under a variety of light conditions, color slide films usually are designed for specific light sources—daylight or tungsten. Otherwise, unless you use conversion filters (see page 94), the subjects in your slides probably will appear in different colors from what you saw when you photographed them.

The reason is that our eyes easily adjust to the different colors emitted by different light sources, but most color slide films do not. Instead, they are *color-balanced* by the film manufacturer for specific light sources. *Daylight color*

*films* are designed for use with sunlight, electronic flash, and blue flashbulbs. Indoors, when subjects are illuminated by ordinary household incandescent lights (not fluorescent), *tungsten color films* give the best results.

What happens when you use a tungsten film outdoors in daylight? Everything has a bluish cast and the picture looks very unnatural. Likewise, a daylight film exposed indoors with incandescent light will have an unattractive yellowish orange cast. Although these abnormal colors can be corrected by shooting with a filter on your camera lens, usually it's much easier just to use the color slide film that's balanced for the light you're using, daylight or tungsten.

Also keep in mind that when you photograph with color slide film under fluorescent lights with either tungsten or daylight film, you'll need to use a filter to get the best colors in your picture. Otherwise everything will have a sickly greenish cast.

Aren't there also different *color print films* (also called *color negative films)* to use with different types of illumination? No. The reason is that any untrue colors in the negative can be changed to a considerable degree by filtration during the printing process. The photofinisher gets the correct color balance for you.

*To take excellent photos indoors by natural light (without flash), shoot with a high-speed film, such as an ASA 400 film.*

Black-and-white films also can be used indoors and outdoors under various types of illumination, because colors are recorded in black, white, and various shades of gray.

Anything else to consider when choosing a film? Especially important is the *speed of the film*—in other words, how sensitive the film is to light. As you'll recall, this is indicated by a film's ASA number. The higher the number, the more sensitive the film.

Both color and black-and-white films are classified in general terms regarding their speed: slow, medium, and high (or fast). Films with speeds of ASA 25 to 32 are called slow-speed films. Medium-speed films include those with an ASA of 64, 80, 100, or 125. High-speed films (sometimes called fast films) have an ASA of 160, 200, 320, or 400. Ultra-high-speed films are black-and-white films with ASA 1000 or higher.

*Medium-speed films* (from ASA 64 to ASA 125) are the choice of most photographers for casual shooting outdoors in daylight and indoors with flash. Numerous black-and-white, color print, and color slide films are available in the medium film speed range.

Faster *high-speed films* are most useful when the level of light outdoors or indoors is very low. And they're a good choice when you need to use a faster shutter speed to stop the action, or a smaller f/stop to get greater depth of field.

*Slow-speed films* work well when light conditions are very bright, as at the beach or on the ski slopes. And they are excellent for portraits, landscapes, and still lifes or whenever subjects aren't moving very much. A tripod will help you keep the camera steady when using a slow-speed film.

How much faster or slower is one film when compared to another? The film speed (ASA) numbers will tell you, because they are proportional. For example, an ASA 200 film is twice as fast (i.e., sensitive) as an ASA 100 film, and an ASA 100 film is twice as fast as an ASA 50 film. Another way to compare these speeds is to say that the ASA 200 requires only half the amount of light for exposure as the ASA 100 film.

In order to make better pictures, you can apply this knowledge about film speeds to the exposure relationships of lens openings and shutter speeds (see page 61). When you switch from one film to another film that's twice as fast, you need only half the amount of light to make the exposure—and that allows you to change to the next smaller f/stop in order to increase depth of field, *or* switch to the next faster shutter speed in order to stop the action better. As you know, using a different f/stop or shutter speed often can make the difference between a good picture and a bad one.

What if the lens opening or shutter speed still isn't right for the kind of picture you want to take? Then use an even faster film. By shooting with a film of ASA 400 instead of ASA 100, for instance, you could reduce the lens opening by two f/stops *or* increase the shutter speed by two speeds.

Something else to keep in mind is that certain films, color or black-and-white,

*As with this elusive bighorn sheep, use high-speed film and a fast shutter speed to stop the action of your subject and avoid blurring caused by camera movement, especially when shooting with a telephoto lens. A high-speed film also allows you to use a small lens opening for greater depth of field in your picture.*

can be rated at higher than normal speeds if they are given *special processing*. That means, for instance, that you can "push" an ASA 400 film to ASA 800 or even ASA 1600 if the entire roll is given extended time in the developer. Some quality is lost, but a film may be worth pushing if it's the only way you could have taken the pictures, as when light conditions are very low or when you need a smaller lens opening or a faster shutter speed. The data sheets packed with film will advise you if the film can be rated at a higher speed, and it will suggest revised ASA numbers for setting the camera's exposure meter. Ask at your camera store about special processing services.

It's good to know that two types of film, black-and-white and color print films, have some *exposure latitude*. This means that even if the exposure you use isn't exactly correct, acceptable prints can be made from the negatives. Different types of papers and filters are used during the printing process to make a good picture from a poor negative. Even a negative that's one or two f/stops over- or underexposed can produce an okay print if you use a custom processor who will take the trouble.

You'll have no such luck with color slide films, however. The film that's exposed is the slide that's projected; there's no middle step where exposure mistakes can be corrected, as when negatives are printed. So you have to pay close attention to exposure when you use color slide film, because even a one-half or one f/stop mistake can produce a disappointing picture.

*Some films have enough exposure latitude to produce a good print despite difficult light conditions or an incorrect exposure.*

If you're taking a very important picture, regardless of the type of film you're using (but especially if it's color slide film), you may want to do what the pros do—*bracket exposures.* That means you take a picture at the exposure that should be correct, then take a few more at different exposures. Purposely overexpose and underexpose by one-half f/stop or one full f/stop.

If your camera features automatic exposure and has no override to let you set exposures manually, you can bracket by changing the camera's ASA film speed setting. After your initial exposure at the film's correct ASA, double the ASA and reset the film speed dial to that number in order to underexpose automatically by one f/stop. Then divide the original ASA number in half and again reset the film speed dial to that number to overexpose automatically by one f/stop. Afterward, remember to reset the dial to the correct ASA setting.

Remember that the best guide to any type of film, and how to get the best pictures with it, is the *film data sheet* that's packed in the box with some films. You'll find exposure suggestions, advice about filters, developing instructions, and other worthwhile information. Read it carefully.

## Film Precautions

Obviously film is sensitive to light, but it also can be affected by other things. For the best picture results, film needs some tender loving care.

First, keep it cool and dry. Whether the film is loaded in your camera or still in the box, don't leave it in the sun or any place where the film might heat up, like in the glove compartment of a car. It's not necessary to refrigerate the film (except some professional types); just store it in a cool place. Humidity can be harmful, too. Avoid opening the film wrapper, or the storage can for 35mm film, because they're sealed at the factory to protect against humidity until you're ready to load the film in your camera.

Despite what the signs say at airport security checkpoints, X-rays are harmful to films. You'll get strange streaks and crazy colors. Often the machines (especially in foreign countries) are adjusted incorrectly and give too great a dosage. Even minimal X-ray dosages are cumulative, and they can build up to affect your film if it passes through several X-ray machines during an extended trip. The only solution is to ask airport attendants for a visual inspection of your film, and your camera if it's loaded. Carry film separately in a clear plastic bag in your hand luggage so it's easy to remove and hand to security personnel.

When the atmosphere is very dry, as sometimes happens during winter or in

*Take extra precaution with films in wintertime because they can become brittle and break, or marred with streaks caused by static electricity.*

desert areas, static electricity can cause lightninglike streaks on your film. This most often occurs if you advance or rewind the film too fast. Also in winter, if the weather is very cold, film can get brittle and break. The best advice is to be slow and steady when you wind or rewind the film under such conditions.

One thing to watch for when you buy or use film is the *expiration date* printed on the film box. After that date there can be a change in the film's characteristics—especially color and speed. Expired film is often sold at considerable discount but you can never be sure of the results you'll get.

All film manufacturers recommend that film be processed promptly after exposure. The reason is that once the chemical coating of the film has been struck by light to make an image, heat and humidity and the passage of time can alter the film before it is processed. You probably won't notice much wrong unless you wait several months after the film is exposed, or subject it to considerable heat or humidity.

Also remember that *developed film*, both negatives and slides, should be stored in a cool, dry, and dark place. Otherwise their colors may change or the images fade.

One final precaution regarding film: Always have an extra roll or two handy. Photo opportunities often happen when you don't expect them, and many times you'll miss a great picture because you're out of film. Stock up and be ready.

# 6.

# **Lighting Considerations**

Have you ever thought about the light when you're taking pictures? Of course you know that without light there can be no photography, but have you considered the different types of light and their qualities? Good photographers do, because the kind of light that illuminates the subject determines the impact the

*These sand dunes in Death Valley are especially dramatic late in the day when the setting sun highlights their wind-blown shapes and patterns.*

picture will have. It establishes a mood or certain emphasis. When you look through the camera's viewfinder, pretend your eye is the film—study the light and the overall effect it gives.

## Types of Light

What types of light are there? The two broad categories are *sunlight* and *artificial light.* Artificial light is that created by man, including light bulbs, electronic flash, candlelight, and all other non-sunlight sources you might use for taking pictures.

You should also be aware of the different qualities of light. These are described as *harsh, hard,* or *high-contrast light* on the one hand and *soft* or *diffused light* on the other. You'll want different kinds of light to achieve different effects.

*Direct sunlight often is harsh and not very flattering for informal portraits of people, as of this Indian jewelry seller in Arizona.*

*This pleasant portrait of a cowboy on an Arizona dude ranch was taken in the shade.*

Sunlight on a clear day produces direct harsh light that causes high contrast and deep shadows and gives strong detail to a subject.

On the other hand, sunlight on an overcast day produces indirect diffused light that causes lower contrast and fewer shadows and gives softness to a subject. Take pictures of the same person in the bright sunshine and then in the shade (or on a cloudy day), and you'll see the difference that the quality of light makes.

You can control light quality, too. An electronic flash produces a harsh light, but you can soften the effect by bouncing the flash light against a ceiling or wall to diffuse it or by placing a piece of diffusion material over the flash reflector. This can be a diffusion filter made specifically for the flash unit, or just a layer of handkerchief or Kleenex tissue. For portrait work, there are *umbrella reflectors* you can attach to electronic flash units to soften the light.

By the way, you'll hear photographers talking about *natural light, existing light,* and *available light.* They're referring to sunlight or artificial light that is already present and illuminating a subject. In other words, the photographer isn't supplying the light with a flash or bright electric bulbs, although he may redirect some of the existing light by using some sort of reflector.

This fountain appears rather ordinary when photographed from the same direction that the sun is falling on it. (The building in the background is distracting, too.)

When the photographer moved to the opposite side so the sun would be shining through the water, the fountain makes a much more impressive picture.

## Ways to Use Light

Always analyze the light when you're taking a picture. The color and direction of sunlight changes at different times of the day. It's warmer in color and lower to the horizon during early morning and late afternoon. Because of enriched colors and longer shadows, scenic pictures often are more appealing at those times of the day than if taken at midday when the sun is overhead and at maximum brightness. However, portraits taken in sunlight during late afternoon may be disappointing because skin tones are too reddish and facial shadows too long.

To see for yourself how the color and impact of a picture change as the sunlight changes, pick a stationary subject and photograph it during various times of the day. Also, when shooting in direct sunlight, walk around your subject to see how it changes with the direction of the light. For instance, a water fountain looks entirely different according to whether the sunlight is illuminating it from the front, from the side, or from the back. To become more aware of how the direction of light influences your picture results, photograph a subject indoors with a flash or spotlight placed at different angles.

When light falls on your subject from the direction of your camera position, it's known as *front lighting*. Because there will be almost no shadows to give a

*This pensive girl is illuminated by side light coming through an open window.*

feeling of depth and dimension to the subject, this is also called *flat lighting*. Your subject will be well illuminated with front or flat light, but the results are not very dramatic.

A subject photographed with light directed from the side is often more eye-catching. When the light source is either to the left or right of the camera, such *side lighting* creates shadows that give texture and a three-dimensional look to a subject. Make your exposure meter reading of the illuminated part of the subject, not the shadows.

If the shadows are too dark and distracting, a second light, called a *fill-in light,* can be added. When sunlight is your main side-light source, a flash is often convenient to use for fill-in light (see page 113). A reflector, such as a large piece of white cardboard, also can provide fill-in light by bouncing the sunlight (or main indoor light) into the shadowed areas.

When illumination is with two lights of equal brightness on opposite sides of the subject, it's called *cross lighting*. Sometimes a fill-in light is used to reduce

*Pleasant portraits can be made outdoors with back lighting; get close to the subject when you make an exposure reading in order to avoid underexposure.*

the shadow that runs down the middle of a cross-lighted subject.

One of the most effective directions for illumination is *back lighting,* when the main light source is opposite the camera and falls on the rear of the subject. It can be especially nice for informal outdoor portraits when bright sunlight causes your subject to squint. Instead of staring into the sun, have your subject turn so his back is to the sun. Facial expressions are more natural, and there won't be any annoying shadows in the eyesockets or from the subject's nose.

There are two precautions to take when using back lighting. First, be careful the light doesn't shine into your lens and cause distracting flare. Use a lens shade or change the angle of your camera. Also, aim your exposure meter carefully so it reads only your subject, not the back light. If the bright back light falls on your meter's sensor, it will cause underexposure and your subject will be a silhouette. Move in close to your subject to make the exposure reading.

*Top lighting is not a good choice for pictures of people because it makes unattractive shadows on their faces.*

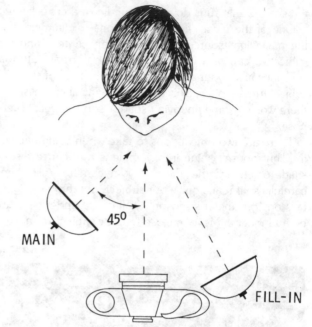

*To make a portrait with two lights, arrange them with the main light closer to the subject than the fill-in light.*

If your camera features automatic exposure, lock in the close-up exposure reading (usually by slightly depressing the shutter release button or using a special exposure lock lever), then move back to the position you want for the best composition. An alternative on some models is to use the camera's automatic exposure override and set the exposure manually while metering your back-lighted subject close up. Other auto-exposure cameras have a back light switch or lever to use that will automatically compensate for exposure when a subject is back-lighted.

Another term you might hear is *top lighting*, when the sun or indoor light source is directly overhead. This type of light is not effective or flattering for people, because their eyesockets usually are in shadow.

Sometime you may want to set up a little studio in your home to take pictures of your family and friends. Studio photographers have descriptive terms for the lights they use. Good portraits can be made with just two lights, called the *main, key,* or *modeling light,* and the *fill-in light.* The main light usually is placed 45 degrees to the right or left of the camera, and higher than your subject's head. As a rule of thumb, if the shadow of the nose touches the subject's lips, the main light is too high and you should readjust it.

To reduce the shadows of the main light and make the most pleasant portrait, a fill-in light is directed at the subject from the camera position. It should be a greater distance from the subject than the main light (or of less intensity) so that it lightens shadows but does not eliminate them.

*In addition to the main light and the fill-in light, an accent light was added to highlight the subject's hair and separate her from the dark background.*

For a little more elaborate lighting setup, you can include one or two extra lights. An *accent light* is used to add highlights to the subject's hair and help separate the subject from a dark background. It's placed high and behind the subject on the left or right side. Check in your viewfinder to make sure the light doesn't shine into the camera lens. If it does, reposition the accent light or use a makeshift shield.

A *background light* gives a portrait additional depth by helping separate the subject from the background. It's placed low and behind the subject, and pointed at the background. The light's intensity and distance from the background determine how bright the background will be in your picture. For professional-quality portraits, a background that's going to be illuminated should be a smooth sheet, a projection screen, a plain untextured wall, or a roll of seamless background paper that's sold in camera stores. Otherwise, keep the background dark so that it doesn't show up in your picture.

Move in close to make an exposure reading of your subject's face, and turn off the background light so that it doesn't influence the reading. If you're using electronic flash, figure exposure based on the distance of the main light to your subject.

*Can you tell what lights were used to make these portraits? Here the subject is illuminated by a main light only, which is aimed from the right side.*

*A fill-in light, farther from the subject and aimed from the left, is added to soften shadows from the main light and illuminate more of the face.*

Usually the main light preferred for portraits gives soft illumination, which means it's a floodlight or a harsher light source that's been diffused by reflecting it onto the subject. When high-contrast light is preferred, use a spotlight or direct light from an electronic flash.

*Photolamps* have long been used for making portraits at home. They look like regular light bulbs but are very bright (300 to 500 watts). You mount them in metal reflectors to direct the light, although some photolamp spotlights have their own built-in reflectors. These days, small electronic flash units are increasingly popular for home portrait work. Let's compare photolamps and electronic flash to see which type might suit you best for occasional indoor portrait photography.

The main advantage of photolamps is that you can see the lighting effects you're going to get in your pictures as you arrange the lights. Also, photolamps are inexpensive, and can be plugged into regular household outlets (preferably on different electrical circuits so the line doesn't overload and blow a fuse or trip a circuit breaker).

As to disadvantages, photolamps are very bright and hot, which may make your subjects uncomfortable. Babies and children are especially disturbed by them. And since shutter speeds for medium-speed films are rather slow (1/30

*A third light, an accent light, was aimed from behind and to the right of the subject to add highlights to his hair.*

*A fourth light, a background light, was placed behind the subject and directed at the background to brighten it and make the subject stand out.*

second or slower) when using photolamps, squirming kids may be blurred in your pictures. Another consideration is that photolamps have a relatively short life of three to six hours.

Also, when taking portraits in color, you should use blue photolamps to get correct color balance with daylight films, *or* put a filter on your camera lens (a blue No. 80B for daylight color films, a yellow No. 81A for tungsten color films). One color slide film, Kodachrome 40 (Type A), is color-balanced for non-blue photolamps and requires no filter.

As for taking portraits with *electronic flash,* the biggest advantages are that flash lights won't bother your subjects, they prevent blurred pictures by stopping any subject movements, and you don't need filters to get color-balanced pictures with daylight color films.

The main disadvantage is that you're unable to see the flash lighting effects until the portrait pictures are processed. To check if the flash units are placed and aimed correctly before shooting, substitute regular light bulbs in reflectors to preview the lighting effects you want to get with the flash units. One other disadvantage is the expense of buying two or more electronic flash units, along with long connecting cords or remote sensors that are needed to fire each unit.

Whether you decide to use electronic flash or photolamps, once you estab-

*Photolamps were used to make this informal portrait of the director of a stage play.*

lish the light positions that give the results you want, it should be easy to set up everything again whenever you want to take a nicely lighted portrait at home.

When considering types of lighting, don't forget about *night exposures*. The moon, moving car lights, illuminated signs, and floodlit water fountains and statues are just a few of the photographic possibilities for your camera after the sun goes down. A good time to take scenic night pictures is just at dusk when the sky is not entirely dark. If you're shooting an overall city view, the twilight sky will add extra life to your photograph of building and street lights.

Of course, night exposures will be longer than those made in daylight, so you'll need a tripod to keep your camera steady. Many cameras with automatic exposure systems do a good job of taking time exposures at night, or you may have to make long exposures manually. In that case, turn your camera's shutter speed dial to B, then use a cable release to keep the shutter open and avoid jarring the camera during the time exposure. Bracket exposures so you can pick the night shot you like best when you see the processed prints or slides.

Night or day, indoors or outside, always study the light to decide what kind of pictures will result—and whether you should change your camera angle or the subject's position, set up your own lights, or just add a little more light with a fill-in flash or bounce light reflector.

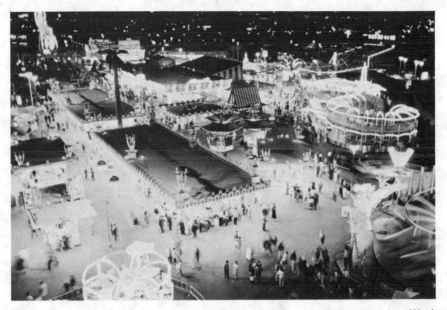

*Night exposures make interesting pictures, as of this brightly lit fairground in Washington.*

# Part III

## Shooting Super Pictures of People and Events

Want to know three easy ways to take better pictures? Here they are: Understand your camera, be concerned with composition, and plan ahead. You've already learned about composition and cameras in Parts I and II of this book, so now it's time to discuss how to plan for picture possibilities. Only a few great photographs just happen—most of the time they are the result of careful thought by the photographer.

Your pictures will improve when you start to think more about your subjects and plan the best ways to photograph them. Following are some suggestions for taking super shots of people and events. They should spark some ideas of your own.

# 1.

# Everyday Subjects

People of all ages that you see every day—your family, neighbors, friends, and fellow workers—are fun to photograph because they're familiar subjects and a challenge to capture creatively with your camera. Let's consider some of the things you can do to make interesting and enjoyable photos of people at various ages. Keep in mind that to really improve your photography, practice "seeing" pictures—imagining all the ways to capture your subject on film. Then have your camera ready to put your thoughts into action.

## Babies

If you wish, pictures of babies can first begin when they do—in the delivery room. Many hospitals permit fathers to be there for the event and photograph it. Shoot by natural light so you won't disturb the delivery procedure. Use a high-speed film such as Kodacolor 400 (for prints) or Ektachrome 400 (for slides).

If hospital regulations won't permit photography in the delivery room, be ready when the nurse brings the newborn infant into the nursery. Signal her to bring him close to the viewing window so you can get a close shot. Use a wide-angle lens and place it against the window glass to avoid reflections. Shoot with

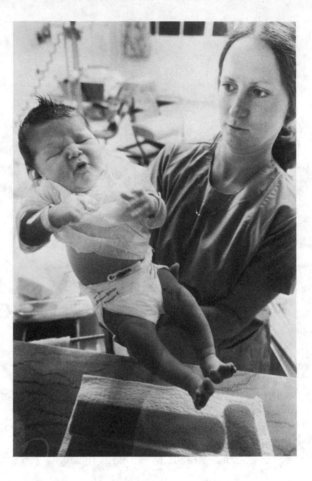

*A nurse held this new-born baby next to the window in the hospital nursery, where the proud father used a wide-angle lens and took this picture by natural light with high-speed film.*

the natural light, because flash will reflect in the glass (or be sure the flash is held against the glass, too). And don't forget to shoot an overall of the nursery room with your baby among all the other infants in their cribs.

In the hospital room, take the first mother-and-child portrait. Use the natural light or bounce flash to avoid disturbing the baby with direct flash. Have the nurse or a friend take a few shots so Dad will be in some of the pictures too. One of those shots could be perfect for a photo greeting card announcing the birth.

When you take the infant home, photograph other children in the family admiring their new baby brother or sister. And don't forget a shot of the happy grandparents holding the tiny bundle.

There are so many photo-worthy activities in a newborn baby's life that you should always have a camera ready to record them. Nursing or bottle time,

*Don't forget to photograph Dad with his newborn baby. To avoid upsetting the baby with bright flash, father and daughter posed near a window and were photographed by natural light.*

crying, getting a bath, sleeping, and rocking the baby are just a few of the photo possibilities. Later you can do a series of shots as the infant learns to eat and to walk.

Dress baby up for a portrait, too. Prop the infant up on a colorful blanket or with pillows near a window so you can take the pictures by natural light. (Don't shoot toward the window itself because the bright light can cause glare or underexposures.) Babies' faces change expression quickly, so you have to be alert, and patient, to get the most flattering or funny photos.

Remember to get close so that the baby fills the viewfinder and film frame. Shoot close-up pictures as well, such as the baby's eyes and tiny hands and feet. A baby's hand held by an adult hand makes an impressive photo.

As babies start to crawl and become toddlers, there will be lots of moments for candid photography—so keep your camera at hand. Remember to watch

*Photograph babies at their own level, and have enough patience to wait for the most amusing expressions.*

*Try some close-up pictures of babies, focusing on their hands, eyes, or tiny feet.*

the background. While you're concentrating on the baby's actions and expressions, it's easy to forget that the background may appear distracting in a picture. An easy solution is to get closer until you fill the viewfinder with just the baby. And be sure to turn the camera horizontal or vertical for the most appealing format.

## Children

Children usually are very active, and you must be quick to photograph them. They may sit still long enough if you want to take an informal portrait, but most of the time you should be ready to make candid photos. Flash can be helpful, since lots of the children's activities will be indoors and flash will capture the action. When shooting portraits with flash, beware of "pink eye" (see page 117).

Keep in mind that children often pose or mug when they see the camera, and their expressions won't be very natural. However, when they're involved with some object or activity, they may not notice you. Also, a telephoto lens lets you shoot some distance away and your camera will be less of a distraction. Of

*Be ready with your camera when children flash their appealing smiles.*

*Kneel down to their level and capture the happy expressions of children at play.*

course, the more often you take pictures, the less the kids will react to your camera and strike an unwanted pose.

Another tip is to photograph children at their own levels instead of diminishing their size by shooting down on them. Kneel, squat, or stretch out on the floor or grass and your pictures will show more personal involvement with your young subjects.

Photograph kids when they're playing in the yard, practicing music lessons, washing the dog, smelling flowers, drawing with crayons, looking out a rain-spattered window, reading a book, dressing up in Mom's hats and shoes, jumping rope, having a tea party, getting a haircut, and being tucked into bed.

The point is to take pictures of children while they're doing everyday activities. They grow up so fast that if you wait to shoot routine or ordinary events, you'll forever be without those memorable photographs. Also, be sure to take several exposures in order to capture the best expressions or have a sequence that shows the child's activity.

*Always have your camera handy to photograph children during their everyday activities, as well as for special events like this horse show where the beaming girl won a first-place ribbon.*

## Teenagers

Photographing teenagers isn't easy. For one thing, many of them are shy or self-conscious about their looks and don't like to have their pictures taken. Teenagers also like to be independent, so Mom and Dad are less likely to be involved in young folks' activities. And parents are rarely welcome when they intrude with a camera.

One way to get pictures of your teenagers for the family album is to encourage the teens to take pictures of themselves. Photography is increasingly popular with young people, so it shouldn't be difficult to get their cooperation. Show them how to use your camera and flash, and supply them with film. Also volunteer to have the processing done. They should be glad to take pictures of themselves and their activities because it isn't costing them anything.

Around home, try to take pictures (a telephoto may help) of your teenagers

*Teenagers often are shy about having their pictures taken, so photograph them involved in an activity. She's cutting up strawberries for the family's dessert.*

*Teens are less inhibited before a camera when they're in a group, like this girls' softball team that's posing for a pre-game picture.*

on the telephone, getting ready for a date, doing homework, learning to drive, and dressing up in a cheerleader or band uniform. When there's a slumber party or other teenage gathering at your house, you may be able to get some good candids, because teens usually aren't so shy or inhibited when they're in a group.

## Adults

Adults usually don't mind posing for photos, because most of them have been on the other side of the camera taking pictures and know how nice it is to have a cooperative subject. Once in a while some adults insist you shoot only their most flattering side. Or they won't smile because they have bad teeth and don't want them to show, or they object to close portraits because of wrinkled skin.

It's important that your subjects be comfortable and look relaxed. Sitting down and leaning against something are two informal postures that work well with adults. Unless you're shooting a portrait, show grownups engaged in some activity, such as working around the house, enjoying a party, or being engrossed in a hobby.

For portraits, be sure the light is flattering and not too harsh so that eye-sockets aren't dark and skin texture isn't unattractive. To smooth a person's complexion, use a soft-focus filter over the camera lens. And shoot from a

*An outdoor setting is ideal for portraits of adults.*

*Don't miss the chance for some good candid photos of adults when they're working around the house.*

higher angle if a double chin is too evident. Joke with your subject and try to get natural expressions instead of a frozen face. Also, look out for shadows or reflections from eyeglasses.

## Families

Family group shots will be some of your most cherished photos. Try to take them on a regular basis, or at least once a year. Establish a group shot "tradition" so no one in the family will object to being in the picture.

It takes planning and patience to get a good family picture. Arrange everything in advance so that people won't get restless waiting for you to get the camera ready. Use a tripod for consistent composition, and so that you can activate the camera's self-timer and be in the picture yourself. Better yet, have a

Usually it takes patience and plenty of film to get a pleasing family portrait.

But the effort and expense is worth it when the family photo turns out like this.

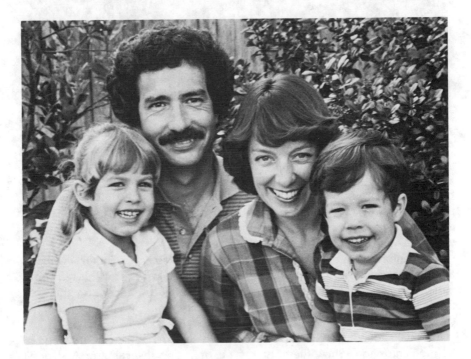

friend trip the shutter after you have everything set and take your place with the group.

Place people so that every face can be seen clearly from the camera position. Sometimes it's best to separate the children to keep them from playing around with each other.

The most difficult thing is to get everyone looking at the camera all at once. Invariably someone, usually Mom or Dad, looks down to check the baby or the kids and ruins the picture. Tell everyone to keep his eyes on the camera, no matter what. Avoid saying "Hold it!" or the expression will be stiff.

*The bigger the family, the harder the photographer has to work to make sure everyone's attention is directed toward the camera.*

Try to keep everyone relaxed long enough to take a number of exposures. Don't let the group think you're going to shoot only one or two pictures—prepare them by saying you're going to take a half-dozen or more. There's always the chance that someone will look away or close his eyes and spoil the picture, so shoot extra exposures for insurance.

More informal family pictures will be keepsakes too. Gather everyone around the snowman that the family has made, or in front of the tent on a family camping trip. Arrange people randomly but close enough together that the picture features the family and not the scenery. Again, use a tripod and the camera's self-timer so that you can be in the picture too.

Informal shots of the children with each other or the family pet are wonderful momentos too. Show them interacting or facing the camera. And don't forget to take pictures of grandparents.

As always, when the point of the photo is to show faces, keep the people

*Faces are the most important aspect of family photos, so move in close with your camera.*

close to each other, move in close with your camera, and avoid an unattractive background.

If you're the chief photographer of the family, you'll be left out of most pictures. Show someone else how to use the camera so that you'll be represented in the family album too.

## Pets

Pet dogs and cats and birds are just like members of the family and are very appealing subjects. But you'll need lots of patience to get good photos of them. Start by watching their daily habits and visualize the best pictures. Get down to an animal's level, or coax it into higher places so you can shoot up at it. As usual, watch out for a distracting background.

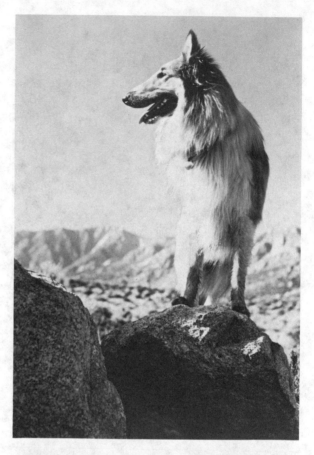

*Pictures of pets will be more unusual if you photograph them from a low angle.*

*Crinkling a piece of paper is one way to attract the attention of your pet.*

Often it's a good idea to use a "prop" to keep your pet's attention, such as a rubber ball for a dog, a roll of yarn for a kitten, or a silver bell for a bird.

*Photos of pets can be especially appealing if you include a child in the picture, too.*

Crinkling paper or making another noise can get the animal to look alert. Another person can assist you by holding the pet's attention and keeping the animal from moving out of camera range. Then you can concentrate on expressions and action.

Including a child in the picture will add extra appeal to pet photos. Remember to get in close to your subjects. Use a fast shutter speed, or flash, because animals and kids won't sit still very long and you'll want to freeze their actions.

For close-ups of parakeets and other pet birds, shoot through an open cage door or take your feathered friend out of the cage. If your camera frightens the bird, use a telephoto lens and shoot from a greater distance.

Pet fish also can be photographed. If you're using a flash on the camera, shoot at a 45-degree angle to the aquarium so there won't be any reflections

*In or out of their cages, parakeets and other pet birds make colorful subjects for your camera.*

from the glass. An off-camera flash on a long cord is more useful. That's because you can shoot straight on while the flash is held at a 45-degree angle or placed directly above the aquarium to illuminate the fish. Focus on a particular spot and wait for the fish to swim past.

# 2.

# Special Events

All too often people forget to photograph everyday subjects, but they'll always be ready with their cameras for special events like birthdays, weddings, graduations, and vacation trips. To get the best pictures, you should plan carefully what you want to capture on film.

## Birthdays

It's fun to photograph the birthday celebrations of every member of the family and have a year-by-year record as each one grows older. And the annual event

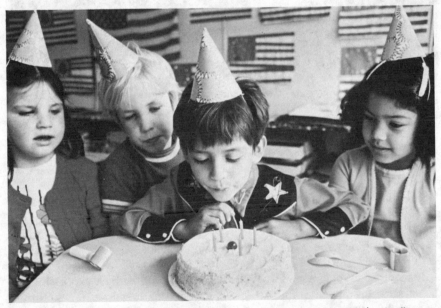

*At birthday parties, be ready to capture the moment when the cake's candles are blown out.*

*Birthdays are a good time to take individual candid pictures of family members and friends.*

is more enjoyable to recall if you shoot more than just the usual cake-and-candles photo. Be set to take lots of pictures, especially at children's birthday parties, where there is so much activity.

Start with shots of baking or frosting the birthday cake, or lighting the candles before the cake is presented. Be focused and shoot quickly just as the candles are being blown out. Afterward, gather guests around the birthday person for a group shot. Then resume taking candids as the cake is cut and consumed.

Be ready when the presents are opened, but wait for the best expressions as the gifts are unwrapped. If the kids are involved in party games, take informal shots as they play. Don't forget to take full-length pictures that show the person's birthday clothes and also overall views of the party decorations. If you're

*Be sure to photograph the birthday person all dressed up in his or her party clothes; flash was used to illuminate this pretty little girl.*

shooting with flash, put in fresh batteries before the party, so you won't miss any once-in-a-lifetime moments.

## Weddings

A wedding is an ideal event for taking a series of photos to make an informal picture story that your family or friends will enjoy for years to come. It's more fun if you're not the "official" wedding photographer, because covering a wedding like a professional photographer can be exhausting work. Besides, you don't want the bride and groom to be unhappy if some of your shots don't turn

*Don't substitute for a professional wedding photographer, but take photos to present later as gifts to the bride and groom.*

out. Better to concentrate on candid pictures and let a pro be responsible for the formal wedding shots.

A good idea, however, is to visit a photography studio to look at its sample wedding albums to see the types of photos you also might take. These usually include not just the wedding party posing for pictures, but the bride putting on her veil in a mirror (shoot at a 45-degree angle to avoid flash reflections) and going down the aisle with her father, and the newlyweds being showered with rice after the ceremony, cutting the wedding cake at the reception, and going off in their "just married" car.

However, instead of following the professional photographer around and duplicating all his shots, be alert for candid pictures he's missing or doesn't have time to take. Concentrate on all the family and friends who've come to the wedding, especially at the reception when everyone is relaxed and having a good time. People will be happy to pose for you, but try to capture them unaware so their expressions are more natural. Use a medium or zoom tele-

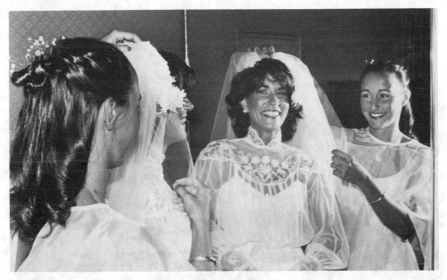

*Stand to one side to avoid reflections when taking the traditional picture of the bride putting on her veil in front of a mirror.*

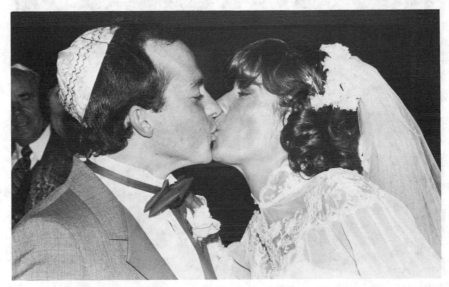

*Have plenty of film and carry extra flash batteries so you won't miss any opportunities for candid wedding pictures.*

photo lens in order to fill up the viewfinder with your subjects. Carry plenty of film and extra flash batteries.

After your photos are developed, have prints made of the best pictures and organize them in an album to give to the bride and groom. They'll enjoy having such lasting memories of their wedding day and will appreciate your thoughtfulness.

## Graduation Day

Another special event to record with your camera is graduation day. Make it a picture story to cherish as the years go by. Start with a portrait of the graduate in cap and gown. At the graduation ceremony itself, get as close as possible to the spot where the diplomas will be awarded, then be ready to shoot when the graduate comes along.

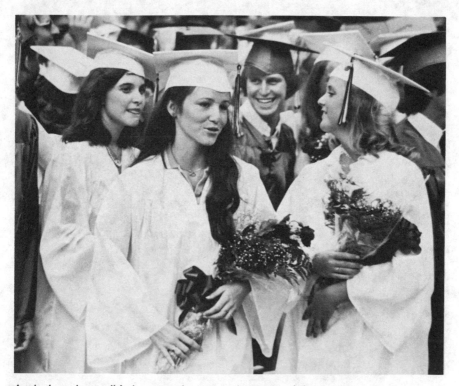

*A telephoto lens will help you pick your graduate out of the crowd.*

If you have to sit far away in the audience, try to capture the diploma presentation with a telephoto lens. If you're indoors or it's dark and you must use flash, be sure your graduate is within the flash unit's range—or else the pictures will be dark and you'll just waste film. If your flash won't reach that far,

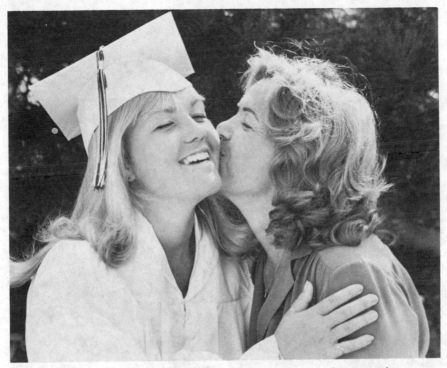

*Capture the moments when family and friends congratulate the happy graduate.*

put the camera on a tripod and use high-speed film with the existing light. Shoot some general pictures of the graduating class and ceremonies, too. Use the existing light, because a regular flash will not illuminate a large area.

After the ceremony, photograph the happy graduate with family and friends. If it's sunny outside, watch that the cap and tassel do not make shadows on the graduate's face; you can use fill-in flash to avoid this. Also have the graduate hold up the diploma so you can take a close-up of it. And be sure to take your camera along to the graduation party.

## Vacation Trips

Almost everyone takes pictures on vacation trips, but the challenge is to get some really great travel photos instead of just snapshots. This is especially important if you're shooting slides to show to friends—unless you want them to become ex-friends! For memories in your vacation photo album, shots with family members facing the camera are traditional. Try to have them doing something, however, instead of just posing stiffly for a picture. For travel pictures you intend to show others, feature local people instead of your family all

*Add more interest to your travel pictures by including local people, such as this young Guatemalan weaver at Lake Atitlan.*

the time. Or at least sometimes have the family facing toward the main subject of your picture rather than staring at the camera.

Before you go on a trip, do a little research and give some thought to the pictures you might take. Look at travel books and brochures to discover the most interesting sights and landmarks to photograph. Study what people are

*Be alert for eye-catching scenes on your vacation, like this lake reflection taken at a resort in the Sierra mountains.*

wearing and doing. Once you get on the road, browse through the postcards for sale to see what subjects professional photographers have chosen to photograph. You'll get some ideas for interesting camera angles, too.

Instead of random shooting, think in terms of topics and then look for appropriate subjects. Besides family shots and ever-popular sunsets, here are some other vacation-trip topics: people (engaged in activities and also close-ups of their faces), clothes and costumes, pets and farm animals, wildlife, flowers, landscapes, food, markets, restaurants, hotels, festivals, sports, occupations, transportation, music, handicrafts, art, architecture, and churches and religious subjects.

A vacation trip gives you a chance to follow all the guidelines for good composition. Use leading lines, frame the subject, include size indicators, vary the picture format, change the camera angle—and try the other composition suggestions discussed in the first part of this book.

On your trip, take pictures regardless of the weather, or the time of day. Don't put the camera away because it's raining or nighttime. Otherwise you

*Wherever you travel remember the guide-lines for good composition, such as framing your subject, as was done in this picture of the Eiffel Tower in Paris.*

*Look for good travel shots any time of the day or night. This couple was sharing a drink from a coconut at sunset on a Mexican beach.*

might miss some good shots. Use a tripod and/or high-speed film for night shots or for indoor pictures on dull days. Outdoors, choose a camera angle that avoids gray skies, and use flash to brighten people's faces. (Use an umbrella or plastic bag to protect your camera from rain.)

Look for signs or flags to include in pictures to title or identify a place or subject. Also, trace your route on a map and take a close-up of it to show exactly where you traveled. When you're back home and your pictures are processed, organize them by topics instead of the chronological order you shot them. That way your photo album or slide show will be much more interesting for both family and friends (see pages 213 and 224).

# 3.

# Holiday Activities

Holidays are times when most people bring out their cameras. Annual events like Christmas and Thanksgiving are festive occasions that offer all kinds of picture possibilities. But don't snap the shutter haphazardly. Think ahead what the best photographic moments might be so you'll be ready to shoot and can compose carefully. Also, make sure your camera, flash, and other equipment are in good working order (check the batteries), and be sure to have plenty of film on hand.

## Christmas

The Christmas season usually is the time of the biggest family holiday, so keep your camera handy for all the activities. Take pictures when you're decorating

*After you decorate the Christmas tree, take close-ups of your favorite ornaments.*

*Have your camera set to shoot when the children are ready to open their presents.*

the tree, including close-ups of the ornaments, and a time exposure of the tree with just the Christmas lights on. Afterward, gather the family in front for a happy group shot with flash. Don't forget to photograph the wreath on your front door and other decorations around the house.

Baking Christmas cookies is great fun for the kids and your camera. Take a camera along when you go shopping, especially for the moment when your kids sit on Santa's lap to tell him what they want for Christmas. Shoot the busy shopping scene (a slow shutter speed will show rushing shoppers), and take time exposures at night of Christmas displays around town.

On Christmas eve, photograph stockings hung by the fireplace and the milk and cookies left for Santa. Next morning, be there with your camera when the kids rush to the tree to open their presents. Sit on the floor at their level and look for candid expressions before you shoot. (Also watch that the background isn't too cluttered.) After everything is unwrapped, make a point to take individual pictures of each family member with his or her presents.

*Take your camera to Christmas parties and photograph all your friends.*

Have your camera ready again to photograph the Christmas dinner being prepared in the kitchen and served at the table. Before dinner, when everyone is nicely dressed, is a good time to take a family group shot (see page 156). Remember to take pictures of guests who visit during the holidays, and the Christmas parties. The more photos you shoot, the more you'll enjoy Christmas memories in the years to come.

## New Year's

Parties are the main event of the New Year's holiday—as well as recuperating the next day while watching football bowl games on television. Be sure that flash batteries are fresh and you have plenty of film when you take your camera to the evening's celebration.

Begin with a "before" shot of the party decorations and full bottles of champagne. Take candids of your friends during the party, and hand them the camera to take pictures of you. Be ready as the clock reaches midnight to capture the shouting, kissing, and merrymaking. Try to include a sign with the new year's date in one of your shots. If you're watching television with the traditional countdown and celebration in Times Square, you can take an exist-

*Bounce flash was used to photograph these celebrants at a New Year's Eve party; have fresh flash batteries and extra film so you won't miss any of the once-a-year festivities.*

ing-light (not flash) exposure of the picture on the screen. Use a tripod and shoot at 1/8 second with single lens reflex (SLR) cameras or 1/30 second with other types of cameras (at faster shutter speeds, black horizontal lines will be evident in your photo of the TV screen).

Finish up with an "after" shot of the party favors and empty champagne glasses, and save a few exposures for the next day as you and your friends relax or sleep in front of the TV set.

## Easter

Easter is an especially colorful holiday, so have plenty of color film on hand. Photograph the kids intently coloring their Easter eggs and do close-ups of their creations. An Easter basket and decorations are good photo subjects, too. And there will be lots of opportunities for candid pictures of the kids during an Easter egg hunt. Focus on the spot where an egg is hidden and wait

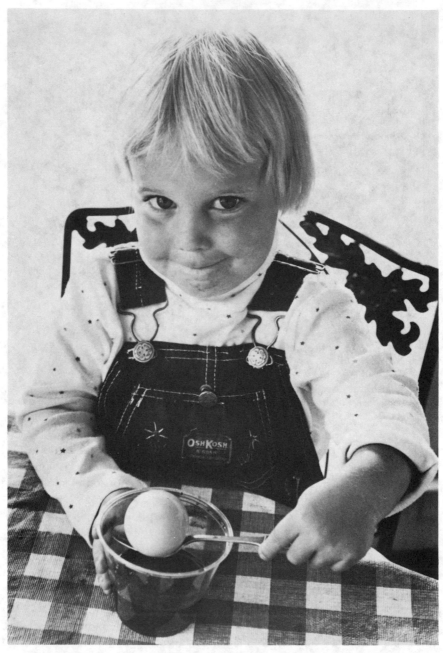

*Kids coloring Easter eggs make an engaging photograph.*

*Also take a close-up picture of the girls in their Easter bonnets.*

for the excited expressions when someone discovers it.

Also get shots of everyone dressed up in Easter finery. This is a good time for portraits of the children, especially if the girls are wearing Easter bonnets. Include the basket with their eggs and candies for extra color and interest. But remember to get close and fill up the viewfinder with your subject.

## Fourth of July

Independence Day is a time to use your creativity, because you have all sorts of subjects and activities. Start with a picture of a family member putting up the American flag. Be on hand if there's a Fourth of July parade. If it's difficult to shoot over the heads of the crowd, put your camera on a tripod, trip the self-timer, and raise the camera overhead by holding onto the tripod's legs until the shutter goes off.

July Fourth picnics and backyard barbecues give you a chance to photograph your family and friends having fun. With a telephoto or zoom lens, shoot close-up candids of their faces as they devour hamburgers, hot dogs, and watermelon. At night, photograph the fireworks display. If you have sparklers, ask each child to spell his name with one and leave the shutter open for a time exposure. For the aerial fireworks, with your camera mounted on a tripod, point it skyward, set the lens aperture at f/8 or f/11 for medium-speed film,

*A bonfire or barbecue on the Fourth of July is ideal for a nighttime photograph; flash was used to add to the fire's illumination.*

*Fireworks can be photographed as a time exposure with the shutter set on B (see text).*

and open the shutter for a time exposure (use the B setting—see page 61) just as the firework explodes into color. Close the shutter when the firework fades. For some exposures, keep the shutter open for several bursts.

## Halloween

Children are in the spotlight at Halloween, and they'll be the stars of your pictures. Show them picking out a pumpkin and then carving it at home. Light a candle in the pumpkin at night and photograph the jack-o'-lantern's face without flash. Shoot full-length shots of the kids in their costumes and close-ups of their faces.

Take pictures of other trick-or-treaters when they come to your door. When your kids come home with their treats, spread everything on a table and have them pose with their colorful loot. If they go to a Halloween party, capture them in action bobbing for apples or playing other games.

For a special effect, place a light or your flash below a devil, witch, or monster's mask so the person looks especially evil. Or you can make *double exposures* with a person dressed in a sheet so it looks as if there is a ghost in

Take your camera along when you go with the kids to pick out a pumpkin for a Halloween jack-o'-lantern.

Photograph your children in their trick-or-treat costumes during the daytime or with flash at night.

*Halloween is an appropriate time to stage a ghost picture, which requires a double exposure (see text).*

the picture. After putting your camera on a tripod, set the shutter to B and the lens opening to one-half the regular exposure with flash. Open the shutter, fire the flash, then cover the lens with your hand (don't move the camera). Next, move the sheet-covered person into the picture, uncover the lens, fire the flash again, and close the shutter. The "ghost" receives only half the picture's total exposure, so whatever is behind the ghost will show through in the photograph.

## Thanksgiving

As at Christmas, another chance for good family pictures is during the Thanksgiving holidays. Tell everyone you plan to take a family group photograph so they'll be ready and not object. Shoot *before* everyone has eaten a big turkey dinner and is too tired or relaxed to pose for you (see page 156).

Since lots of activity at Thanksgiving time takes place in the kitchen, that's where you should be with your camera. If it's a small kitchen, use a wide-angle lens. Photograph the food being prepared, and the turkey as it's taken from the oven. Include the proud cook.

Shoot another when the turkey is being carved. Then back up and get an overall view of everyone at the table, using existing light or bounce flash for uniform illumination. Do this before anyone starts to eat or you'll get people with forks and spoons in front of their faces. After the meal, photograph the unfortunate folks who are doing the dishes and others relaxing after the big meal. And don't forget a shot of the kids pulling on the turkey wishbone.

*Be in the kitchen on Thanksgiving when the cook samples the first bite of turkey.*

# 4.

# Seasonal Shots

The years pass rather quickly, and it's worthwhile to take pictures on a regular basis instead of just during the holidays and on special occasions. One way to plan using your camera throughout the year is to think about the photographs you can take during different seasons.

## Winter

Many people put their cameras away in winter, unless it's Christmastime (see page 174) or unless they go on a skiing holiday. But you have many other

*For some memorable family photos, join the kids when they're playing in the snow.*

*Even if you don't ski, you can have fun photographing at winter resorts.*

opportunities to take some excellent pictures in the colder months. Snow itself is a beautiful subject. After a snowfall, capture the winter wonderland with shots of tree branches laden with fresh snow, patterns made by snowdrifts, snow-flakes on frosted window glass, footprints in the snow, and dripping icicles.

Show the kids all bundled up in their snowsuits. Shoot when they're engaged in some activity, like building a snowman, going for a sled ride, having a snow-ball fight (use a telephoto lens!), or shoveling the walk. Remember that bright hats, scarves, and other clothing will add color to your pictures of people in the snow.

When the children come in from the cold, take close-ups of their red noses and rosy cheeks. And photograph them warming their hands and feet by the

*Wintertime offers many opportunities for scenic shots; a cross-screen filter created the star effect around the sun shining through this windblown tree.*

fire or drinking a steaming mug of hot chocolate. In the early evening, shoot from outside through a frosty window to show the family warm and cozy inside. Or have them come to the window and use it as a frame for an informal portrait.

Also in winter you can set up a feeder outside a window and photograph birds while they're eating the food. Use a telephoto lens and keep the camera on a tripod at the window so you're ready whenever a bird arrives. Get the lens close to the window so you and the camera are not reflected in the glass. You may have to shoot from behind the window drape or shade so that your presence doesn't disturb the birds. By the way, precautions for using your camera and film in cold weather—as well as warnings about over- and underexposure when shooting in bright snow conditions—were discussed in the first part of this book. See pages 77 and 129.

## Spring

Springtime is full of color and activity, and you can preserve it all with your camera. Nature puts on a delightful show. Take close-ups of flowers and tree

*Blossoming flowers, like these poppies, are colorful subjects for springtime pictures.*

*A kite soaring high in the sky makes an arresting picture, especially when a polarizing filter is used to darken the blue sky.*

buds as they begin to blossom. Photograph the family planting a garden. Make a trip to the country or zoo so you can take pictures of colts, lambs, and other animals that are born in the spring. Look for a nest and photograph the baby birds as they hatch or chirp for their dinner.

Even spring cleaning around home is a subject for your camera. Show each member of the family doing his part. On a breezy day, buy some colorful kites and photograph your children at play. If possible, go along with the kids on spring outings from school and get some candid pictures of them and their classmates. (For picture ideas at Easter, see page 177).

*This springtime shot wasn't just good fortune. The butterfly was captured, put in a freezer to make it sluggish, then placed on the girl's nose. (After the picture was taken, the insect flew away.)*

Scenic shots are ideal in spring, because days can be clear and bright and the skies extra blue. Use a polarizing filter to make the sky even richer and to emphasize billowy clouds (see page 94). Spring is a beautiful time for family excursions to the park for a picnic and some ball playing and Frisbee tossing—plenty of action to capture on film.

Don't put your camera away on overcast days or when there are spring showers. Landscapes have a special mood, and reflections make unusual subjects. Children look adorable in their raincoats and hats or holding big umbrellas. Also, photograph them splashing in puddles or staring from a rain-splattered window. Protect the camera and lens from raindrops with an umbrella or plastic bag, and if your camera gets wet, be sure to dry it off before you put it away.

## Summer

Outdoor activities are the essence of summertime and a good reason to have your camera handy. Daylight hours are longer and the kids are out of school, so you'll have plenty of opportunities to take more family pictures. Around home, shoot your backyard barbecues, kids playing in the water sprinkler, your teenagers washing the car, Dad taking a snooze in the hammock, and Mom enjoying a glass of iced tea.

When everyone heads for the water—a swimming pool, the lake or the beach—bring extra film, because there will be lots of action shots. Use a telephoto lens as family members jump off the diving board, try their skill on water skis, or concentrate on catching a fish. Shoot informal portraits of your children emerging from the water in their masks and snorkels or sunbathing on their beach towels.

Go for a nature walk and bring your macro or close-up lenses along. A small padded knapsack is a convenient way to carry your camera and equipment on a hike. Plan a leisurely outing on the trail so you have time to look for nature subjects and the patience to photograph them.

A family campout is another chance to get nature shots. On a dark but clear night, mount your camera on a tripod and point it toward the North Star, set a wide lens aperture such as f/4 or f/5.6 for medium-speed film, then open the shutter (use the B position) for a one-hour time exposure. The picture—streaks of color from the stars—will be fascinating.

Of course your camera is one of the most important things to have on the Fourth of July (see page 179) and to bring along on a summer vacation trip (see page 169). But don't forget it even on short summer drives near home where you might find colorful vegetable stands along the roadside or farmers harvesting in the fields. On summer evenings, be ready for spectacular sunsets. Shoot the sun as it touches the horizon, and then wait until the clouds turn brilliant shades of red and orange.

Sailboating in summer presents photographic challenges, such as keeping your camera dry and making sure the horizon isn't tilted.

Get close-up shots of people engaged in summertime water sports, such as snorkeling.

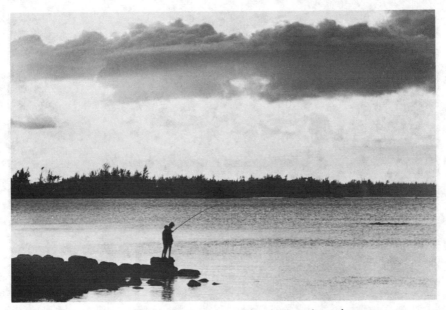

*A silhouette of two boys fishing at sunset portrays the lazy days of summer.*

By the way, on very hot or humid days, be sure to take precautions with your camera and film; see the earlier advice on pages 77 and 128.

## Fall

When Mother Nature turns leaves from green to red, yellow, and gold, head outdoors to preserve the colorful fall foliage on film. Capture the leaves as they fall from the trees or show the multicolored trees reflected in a lake. Shoot close-ups of bright leaf patterns, too. It's also a good time for pictures of family fun—the kids rolling in the leaves that have fallen on the ground, or raking them up.

For more color shots in autumn, go to an orchard where the family can pick apples or other fruit. Photograph them picking in the trees and then with a bag filled to the brim with fruit. Fields or roadside stands with pumpkins offer other attractive pictures that will be reminders of the season. (Also see pages 181 and 183 for photo ideas at Halloween and Thanksgiving.)

When school reopens in the fall, don't forget shots of your children all dressed up in their new clothes. And it will be a special day to photograph if one of them is going to school for the first time. Also, on autumn weekend outings with the family, your pictures will be more appealing if everyone is dressed in colorful sweaters or jackets.

Trees with golden or multicolored leaves inspire photographers in the fall months; the couple adds extra interest and gives scale to this picture.

Side light illuminates this display of Halloween pumpkins, and a wide-angle lens was used for great depth of field so they would all be in focus.

# 5.

# Occasional Outings

During the year there are occasional outings you make that are worth preserving on film. These include parties, school events, spectator sports, picnics, parades, the zoo, amusement parks, the seashore, and hobby and club meetings. Frequently people take snapshots at such events, but you should concentrate on getting some really good pictures. Here are some ideas of subjects to feature.

## Parties

If it's your party, photograph the decorations and the food being prepared before the guests arrive. Concentrate on candids once the party is underway.

*Before people arrive for your party, take a picture of the table setting.*

*Whenever there's a party for a special occasion, like St. Patrick's Day, take your camera along to photograph the celebrants.*

Stand on a chair or get high enough for overall shots of the party scene. Then photograph couples or small groups. Informal posed shots are okay if people show some action, such as toasting each other with their drinks. (Make sure the glasses don't block their faces.)

If there's an opportunity, try to get everyone in a group shot. This will depend on the size of the party, how much room there is to arrange the group, and whether organizing such a picture will be too much of an interruption. If you're a guest, be sure to take some candid or posed photos of the host and/ or hostess and send them prints as a thank-you.

You're certain to need flash (make sure the batteries are fresh), unless the room has bright illumination and you use high-speed film, or the party is outdoors. Watch out for busy backgrounds (move close to your subjects) and for flash reflections from windows, mirrors, and shiny walls (shoot at a 45-degree angle to reflective surfaces). For photo ideas at birthday parties, see page 163.

## School Events

A camera is a natural companion at school events, whether you're attending a student play, carnival, supper, assembly, open house, or athletic event. Stu-

*Carry your camera when you're visiting school because there may be a chance to photograph the kids with their teacher in the classroom.*

*A telephoto lens was used to photograph this school play from the audience. It was shot on high-speed film with the stage lighting, not flash.*

dents should take pictures, too, especially when their parents are unable to attend an event. Make sure they really know how to work the camera (and know the range of the flash), or they'll just waste film.

If you're not familiar with the place where the school event will be held, or exactly what's going to happen, be prepared for any situation. Take along any extra lenses you have, because you might be near or far away from your subjects. Also bring fresh flash batteries plus high-speed film and/or a tripod, because you may decide to shoot with flash or just use the existing light.

To photograph your child in a school play, for instance, you'd probably shoot from the audience with a telephoto lens and use the stage lighting for illumination. Afterward, you might go backstage or to the dressing room and use a normal or wide-angle lens and flash for close-ups of the young actor or actress taking off makeup.

There are school events at home to photograph as well. Take pictures of the kids doing their homework and working on a school project. And do a head-and-shoulders shot of your child holding up an outstanding report card.

## Spectator Sports

Sporting events are exciting to photograph, but you really have to concentrate to get the best action. Anticipate what is going to happen so you'll be ready to press the shutter the instant the action occurs. Also try the various techniques

*Good timing is essential for successful sports pictures. The tennis player and speeding ball were captured with a telephoto lens from the sidelines.*

for showing action in your pictures, as explained earlier on page 33.

To fill up the viewfinder and film frame if you're some distance from your sports subjects, use a telephoto or zoom lens. Change the camera angle if the background is cluttered or confusing. Most important, think about taking more than just the obvious pictures of the event.

For example, your photographs of a day at the races should include more than a few shots of horses in the home stretch or crossing the finish line. Get close and low to the track to show the horses' flying hooves. Shoot bouquet and trophy presentations in the winner's circle. Capture the grandstand spectators during and after a race. Photograph the tote boards, betting windows, and discarded tickets of losing bettors. And look for someone happily holding a winning ticket.

*This panning shot of a horse crossing the finish line is but one of the many pictures that should be taken to tell the story of a day at the races.*

At a football game, photograph the crowd in the stands, the marching band, and the jumping cheerleaders, as well as the football action itself. Regardless of the sports event, try to tell the whole story with your pictures.

Also keep in mind that flash is not much good if you're shooting indoors or at night and are far from the action. (Memorize your flash unit's maximum operating range—see page 102.) Also, flash can be disturbing to the players or participants. Usually the arena or stadium lights are bright enough so you can shoot with the existing illumination and high-speed film.

## Picnics

Use your imagination for creative picnic pictures. Get up in a tree and frame the picnic site through the branches. Or get low and shoot past flowers or

Picnics are a good time to take close-up photos of your family and friends.

Clicking glasses in a toast unites the subjects and puts action into this picnic photo.

plants in the foreground. Bring along a colorful cloth or blanket to cover the table or spread on the ground. Shoot into the picnic hamper before everything is taken out and eaten.

Use a telephoto lens and fill up the film frame with hot dogs grilling on the fire. Do close-ups of people biting into a juicy hamburger and munching corn on the cob. Use a slow shutter speed to show action while flipping a hamburger on the grill or pouring a cold beverage into a glass.

Be ready for a friendly squirrel or birds that come for a handout. Get in the middle of a baseball game for candid shots of the players. If someone stretches out on the grass for a nap, lie down with your camera on the same level for a great slumber shot.

## Parades

Parades offer lots of interesting subjects for your camera, and a chance to try several photo techniques. There can be bright costumes, bands, horses, flags, and floats to photograph, as well as the spectators. Getting a good location on the parade route is very important. Be early so you're in front of the crowd. Consider what will appear in the background when you select a location. Remember that you want to shoot when parade participants are coming toward the camera, not when they've gone past.

*Select a good spot along the parade route so you can take unobstructed pictures of the participants.*

*Mickey Mouse was photographed with a zoom lens during the daily parade down Main Street in Disneyland.*

A zoom lens will help you include just what you want in the picture, because you can keep the composition the same even as the subject moves toward you (see page 88). Also try panning with a subject as it moves past, in order to make it stand out from the background and give more action to your parade pictures (see page 36).

## The Zoo

A visit to the zoo is an opportunity to get outstanding photos of animals, birds, and reptiles, plus some enjoyable family pictures. A telephoto or zoom lens will

help you isolate the animals and birds from their cages and surroundings. By using the largest lens opening for very limited depth of field (see page 63) you sometimes can obliterate screen wire from a cage that would otherwise appear in the foreground of your picture. Put the camera lens next to the screen.

*The zoo is one place to apply your knowledge of depth of field. This ibis was photographed with a telephoto lens but is hidden behind the wires of his cage.*

*By changing to the largest lens opening to limit depth of field, the wires went out of focus and literally disappeared!*

Early morning and late afternoon usually are the times the animals are most active. Focus and set your exposure, and then be patient and wait for them to do something. Or shoot close-ups of their faces, awake or sleeping. Remember that mothers and their youngsters often relate to each other and will make appealing pictures. It's also fun to photograph some of the animal's skin textures or patterns, like the stripes of a zebra.

If the zoo has a nursery, there's a good chance to get shots of newborn animals. Put your camera lens next to the window glass to avoid reflections and shoot by existing light instead of flash. If you use flash, make sure it is next to the glass, too, so it can't reflect back into the lens. Do the same when you're shooting through glass cages at snakes and other reptiles, or any animal behind glass.

Some zoos have a petting area, and this is the place to get shots of your children interacting with the animals. Remember to kneel down to their level, and watch for the best expressions. Also take some overall views of the zoo,

*A telephoto lens made it easy to capture these lazy zoo lions as they snoozed during a hot afternoon.*

*Photograph the kids as well as the animals at the zoo. This teen apes in front of a gorilla statue at the San Diego Zoo.*

and photograph the kids in front of the cages or displays that feature the big animals, like giraffes. If the zoo offers an elephant ride, it will make a memorable photo for the family album.

## Amusement Parks

An outing to an amusement park provides all sorts of situations for pictures of the family and colorful activities. Start with an informal family group shot in front of one of the park rides while everyone is excited and not tired. Get up high in the Ferris wheel or other sky ride for some overall shots of the park. Photograph the people in costume who work at the park, along with the souvenir and food stands. Shoot close-ups of the kids in their new amusement-park T-shirts and licking away at an ice-cream cone or bright cotton candy.

The various rides give you a chance to use the different techniques to show action in your pictures. Try stop-action, blurring and panning (see page 33). If it's a fast ride you're shooting, prefocus on a certain spot and set the exposure so you'll be ready when the people whiz past. Also shoot (preferably with a wide-angle lens) while you're on a ride, such as the roller coaster or merry-go-

*A fast shutter speed helps stop the action of amusement-park thrill rides, such as this modern roller coaster called the Corkscrew.*

*The photographer panned with this water-flume ride to capture the riders' expressions and show action in the picture.*

round, and let the background be blurred.

Amusement parks can be especially beautiful at night, so take your tripod along to do some time exposures. Concentrate on rides with the most colorful lights. If there is stage entertainment in the evening, make plans to photograph that as well. Finish your day at the park with an "after" shot, probably one of the kids asleep on Dad's shoulder.

## The Seashore

A trip to the seashore is bound to keep your camera clicking. There are people to photograph, and nature's own beauty. Look for patterns in the sand and designs on water-washed rocks along the shore. When the tide is out, wade into tidepools to photograph starfish, sea anemones, and other intriguing marine life. Use a polarizing filter to help eliminate reflections from the water (see page 94).

During an incoming tide, use a slow or fast shutter speed to blur or stop the action of waves crashing over the rocks. A cross-screen filter can make the sun's reflections in the water sparkle like stars (see page 96). And don't forget to photograph those beautiful sunrises or sunsets at the seashore. Be sure to keep the horizon level in your viewfinder.

The marine life in this tidepool shows clearly because a polarizing filter was used to cancel reflections from the water.

A fast shutter speed was used for a midair stop-action shot of this Frisbee player at the seashore.

Crouch down and take shots of the kids building a sandcastle or burying each other in the sand. Photograph the colorful beach umbrellas or cabanas. Use your telephoto lens to fill the film frame with sunbathers. Look for action shots—sailboats at sea, fishermen casting in the surf, swimmers racing in the ocean, joggers running along the beach, and seagulls that want to share a bite of your picnic lunch. If it's late in the day, silhouette your subjects against the setting sun.

## Hobby and Club Meetings

You and your friends probably have leisure-time activities (besides photography) that are interesting subjects for your camera and worthwhile including in the family album. If you're going to a meeting, take your camera along to record the club's activities. Use a wide-angle lens for an overall shot of the meeting, and ask if the members will pose together for a group picture. If your

*You'll find a number of subjects to photograph at club meetings, including guest speakers.*

club has a guest speaker, sit up front so you can take a head-and-shoulders picture. Or wait until after the meeting to photograph the speaker wiith your club president.

If it's a hobby meeting, take close-ups of whatever the members are involved in, whether it's collecting rare stamps, making pottery, sewing clothes, or growing flowers. And don't forget that you can make a photographic collection, too, by shooting pictures of things you like but don't have the time or money to own, such as antique cars or early American glassware.

*People involved in their hobbies, such as this wood carver, can be interesting subjects for your camera.*

# Part IV

## Showing Off All Your Great Photos

For some people the thrill in photography is taking the picture itself. But the real excitement for most folks is looking at the results. There's great anticipation when you get pictures back from the processor and see them for the first time. Then what happens to your prints or slides? Do you just toss them in a drawer? Lots of people do—and they miss the fun of showing off their pictures. There are all sorts of ways you can display your great photos.

Arrange the prints in a durable photo album so they're easy to share with friends. Place your photos under a glass desk or coffee table top, or in a plastic

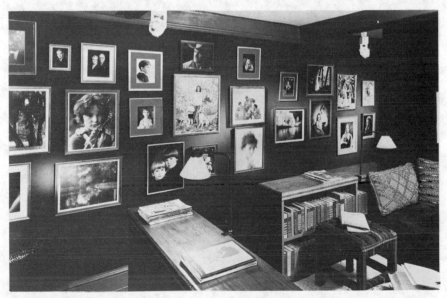

*There are many ways to show off your photographs, such as turning a wall at home into a picture gallery.*

display cube. Have enlargements made and then mount or frame them to hang on a wall. Or construct a room divider to feature your best shots.

Put together a slide show for your family and friends. Turn photos into greeting cards to mail on special occasions. Make a mobile that provides an ever-changing photo display. Have your pictures photocopied on T-shirts or on cloth for pillows. Order a huge photomural made from one of your scenic shots to decorate the den or playroom. At the very least, get a cork- or fabric-covered bulletin board and pin up your latest pictures for the family to enjoy.

Read on to learn more about what you can do with photographs after you get them back from the processor, including how to care for prints and slides as well as display them.

# 1.

# Taking Care of Photographs

Are you careless with photographs? Negatives, prints, and slides need special attention whether you intend to keep them for just a little while or for a lifetime. Negatives and slides are "originals" that cannot be replaced. Handle them carefully by their edges, because fingerprints can mar the images permanently, especially if you touch or scratch the dull (emulsion) side.

For long-term preservation, keep negatives and prints and slides in a cool, dry, and dark place. That's because heat, humidity, and light are harmful to photographic images. This means you should not keep photos and negatives next to heaters or radiators, in hot attics or damp basements, or in bright or continuous light—whether it's from the sun or electric light bulbs (especially fluorescent lights).

Heat, humidity, and light cause the dyes in color prints, slides, and negatives to fade or change tones. Framing pictures behind glass is worthwhile because it helps block the ultraviolet rays that promote fading. Never display prints where they'll receive direct rays of the sun.

You should be aware that of the two popular instant print films, Kodak's PR-10 fades much faster than Polaroid's SX-70. With either instant film, avoid damaging a developing print ejected by the camera by handling it only by the white borders. Also, don't bend, fold, or crush the instant picture or it won't develop properly.

Negatives can be kept in the envelope or sleeve returned to you by the processor, or stored in special negative sleeves and storage envelopes sold at camera shops. Just be certain that dust and dirt can't gather on the negatives and that they won't be accidentally scratched. And be especially careful of tiny 110-size negatives from pocket cameras, because any marks will be greatly magnified when enlargements are made.

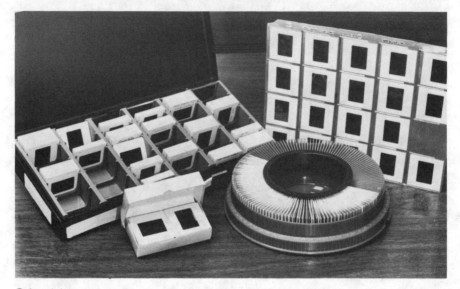

*Color slides can be stored and protected in several ways. Use the boxes the slides are returned in by the processor, put them in larger group slide trays, insert the slides in plastic protector pages, or leave them in slide projector trays (in closed boxes).*

Prints also can be stored in the envelopes they were returned in by the processor. Or you can put them in a photo album for protection.

Store slides in their boxes from the processor, or buy plastic pages that have pockets for individual slides. A protector page the size of a three-ring notebook will hold twenty 35mm or 126-size slides. (It's easy and safe to look at slides with a magnifier when they're kept in such see-through sleeves.) Slides also can be stored in group slide file trays which hold up to 600 cardboard-mounted slides. Or keep them in 80- to 140-capacity slide projector trays stored in their own closed boxes. Camera shops usually carry these and a few similar products you can use to store slides and prints.

# 2.

# Editing and Filing Photos

If you're going to take care of negatives and photos properly, it's a good idea to start a filing system at the same time. That way you'll always know what and where all your images are.

The first place to file some of your pictures is in the wastebasket! Not every shot you take is a keepsake. Whenever you get photos back from the processor, review them carefully (we all learn by our mistakes), and then toss out the ones that are out of focus, poorly exposed, have no meaning, or are otherwise worthless. No need to take up storage space or spend time filing bad pictures. Be critical when you edit—family and friends appreciate not having to look at your lousy shots, and they'll be more complimentary about the good ones you show them.

A filing system can be simple and easy to keep up. Follow a chronological order. Whenever you receive an envelope of prints or negatives or a box of slides back from the processor, write the date, subject(s), and place(s) on the envelope or box consecutively so you can keep them in order.

Next, whenever you remove anything from an envelope or box, write the same number and other information on the back of the print, slide mount, or negative sleeve. That way you'll always be able to identify and later refile a print you show to friends, a slide you used in a show, or a negative you sent out to be enlarged.

To be really organized, keep a numbered master list in a notebook so you won't have to look at all the envelope or box labels to locate a certain subject.

The most difficult thing about a filing system is starting it. Even if your present photo collection is in great disarray, begin a filing system for your new pictures now. It may encourage you to spend time organizing the older photos too.

# 3.

# Keeping a Photo Album

One of the best ways to display and enjoy your pictures is by keeping them in photo albums. The prints are convenient to look at, and they're also protected. And because it's always tempting to thumb through someone's photo album, neighbors and friends will get to enjoy your photography, too.

You'll find a variety of photo albums in stationery, department, and camera

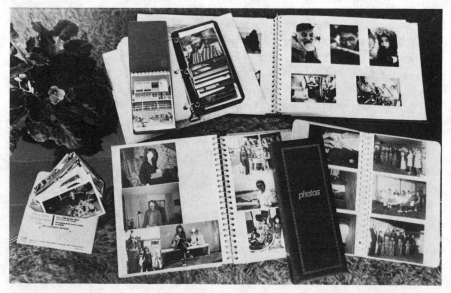

*Photo albums come in a variety of sizes, shapes, and materials. These are a few of the types described in the text.*

stores. Easiest to use is the type with "magnetic" plastic pages that hold the pictures in place without tape or glue. With abuse or considerable use, however, the plastic may tear. Others just have plain pages of thick paper and require adhesive to mount the prints. Some albums feature pockets to hold prints of specific size and shape (square, horizontal, or vertical), but these can limit the arrangement of your pictures. A few are designed specifically for Kodak or Polaroid instant prints.

Look for albums that will accept extra pages so they can be expanded as you fill them with pictures. Because photo albums are kept for years, check their construction to see how well they'll hold up.

If pictures must be affixed to the album pages, make sure you use the correct glue or other adhesive. Don't use rubber cement or glues containing water, because they can seep through some print papers and stain the pictures. One acceptable glue for photos is Kodak Rapid Mounting Cement, available at

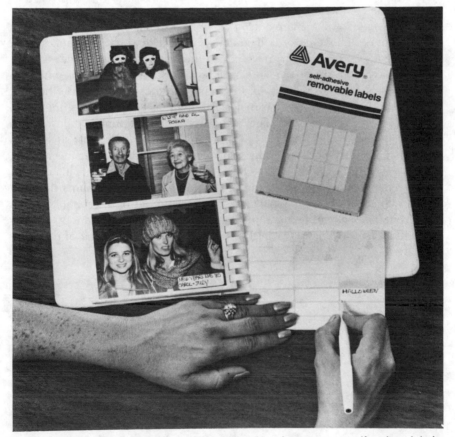

*An easy way to identify your photos is to write the information on self-sticking labels.*

camera shops. Or look in art-supply stores for Scotch Photo Mount spray adhesive, which comes in an aerosol can. There also is a self-sticking mounting tissue you can cut to size and use on the back of prints to affix them to album pages. Double-sided Scotch tape is similar but does not make as strong a bond. Don't use ordinary Scotch tape on the front of photos because it eventually discolors or can tear the print.

After you've chosen an album and are ready to mount the pictures, think about the best arrangement for your photos. An album is more interesting if it has some sort of order. You might arrange shots by category, such as family groups, the children, pets, the house, vacations, and special occasions like birthdays and graduation (see the previous section for other categories). If you take a lot of family pictures, you might keep separate albums for each child. Otherwise, leave blank pages to fill in with photos of the same kind later.

Even if your photos are labeled on their backs, an album is more interesting when the pictures are easily identified. You can write captions in the white border on the face of prints or on the album pages themselves. Use a thin-line permanent ink marker. If your prints are borderless, or your album has plastic pages, or you just want smart-looking captions, use self-sticking labels sold in various sizes at stationery stores. If you make a mistake writing the caption on a label, write another—you won't have ruined the photo or album page.

Many inks won't dry or remain very long on the face of instant prints, so stick-on labels are especially useful for identifying those pictures. By the way, both Polaroid and Kodak pack warnings with their instant print films not to cut, tear, trim, or separate the print. That's because an instant print contains caustic developing fluids that might cause alkali burns or stains. Normally such fluids dry up in a matter of weeks after the print develops, but don't take any chances. When you put instant prints in an album, leave their white borders intact.

And remember to take the same precautions with photo albums that you should with all types of individual prints: keep them out of direct sunlight and away from heat sources and damp places. That way they'll last a long time as wonderful illustrated family chronicles to help you recall a lifetime of memorable events.

# 4.

# Enlarging Prints for Display

Most often photos are returned from the processor as small snapshot-size prints. As you look them over, imagine how impressive this one or that one might be if it was enlarged for display on a wall or table. Don't forget that instant prints also can be enlarged. And enlargements can be made from slides, so review your transparencies with a slide projector to see how they might look as big prints.

What size enlargement should you get? That depends not only on where you intend to display it, but on the size of the negative, slide, or instant print.

Standard enlargement sizes from the tiny 110-size pocket camera films are 5×7 and 8×10 inches. For other rectangular films, including 35mm, as well as Kodak PR-10 instant prints, common enlargement sizes are 5×7, 8×10, and 11×14 inches. Square formats like 126-size cartridge and 120-size roll films and Polaroid SX-70 instant prints usually are enlarged to 5×5, 8×8, or 11×11 inches. The biggest "standard" enlargement size is 16×16 inches for square films and 16×20 inches for rectangular films.

When ordering enlargements you can request they be *cropped* to show only part of the image, or have them printed *full-frame* to include everything on the negative or slide.

For a full-frame enlargement from 35mm films, the actual enlargement size could be 5×7, 7×10, 10×14, or 16×24 inches, as you request. Some processing labs also will enlarge 35mm negative or slides full-frame to 8×12 or 11×16 inches.

If you want to enlarge only a portion of the image, camera stores have *cropping masks* you can lay over the negative or slide to show what will be included in an enlargement in various available sizes. The number of the mask you choose is noted on your order to tell the processing lab how to crop the

*If you don't like everything in a slide or negative, use a cropping mask at the camera store to show the processor exactly how much of the image you want in an enlargement.*

picture. Or you can give general instructions, like "crop bottom" or "enlarge for child's face." Even better is to send along a print marked exactly the way you want the negative or slide cropped for enlargement.

Most processing labs use automated printing machines to make enlargements, so you may have to request *custom enlarging* or go to a *custom lab* to have an enlargement printed exactly as you wish. Of course, custom enlarging always costs more, but the results usually are worth the extra expense. Custom enlarging is a good idea when your negative or slide is a little too dark or too light or off-color, because corrections can be handled by the person making the enlargement.

In general, the processing labs used by camera stores do an acceptable job making enlargements. If you're unsatisfied, ask the store to send the photo back for reprinting. And if you're still unhappy, look in the telephone book for a nearby custom lab. Or buy the latest issue of a photo magazine, like *Popular Photography* or *Modern Photography,* and locate a custom lab by looking through the numerous ads. Also compare enlargement prices in the photo magazine ads with those at your camera store. Frequently you can save money by ordering enlargements through the mail, but test the processing lab by ordering only one or two prints at first to see if you like the results.

Whenever you order enlargements, you must decide not only size but also the *print texture.* Enlarging papers come in a variety of textures or surfaces, often described as glossy, semi-gloss, matte, silk, or canvas. Camera stores have examples of each type to help you decide which texture is best. The one you should choose usually depends on the subject of your picture, the size of

the enlargement, and the place where it's going to be displayed.

Another thing to consider is whether you want the enlargement made with or without *borders* (although some labs don't offer a choice). If you're going to put it behind a mat or in a frame, an enlargement with a border is recommended so that all the image area will be seen. However, if you intend just to mount the enlargement and display it as is, order it borderless so you don't have to trim off the white borders. A borderless enlargement also is the best choice if you're going to put it in a full-view plastic frame.

Remember to carefully choose the pictures you want to enlarge. Besides good composition, make sure the images are in sharp focus. Fuzzy pictures will look even fuzzier when you blow them up to bigger sizes. When selecting slides, use an eye magnifier to inspect their sharpness. Negatives with good contrast and color will make the best enlargements. Color slides enlarge better when they're not too dark and the colors aren't too contrasty.

If you want a very big enlargement made, sometimes it's a good idea to first order a smaller (and less expensive) enlargement to see if you're going to like the picture after all. If you really love a particular shot, consider ordering a huge enlargement or photomural. These can be made 3½×5 *feet* or even larger. Make sure that you have a big wall for display and that the subject of the picture is something that won't seem out of place in the room.

# 5.

# Mounting and Framing Photos

Once you've spent the money to have an enlargement made, remember that it will look better and last longer if it's mounted and/or framed. Mounting gives enlarged photos support and keeps them from wrinkling or curling. Framing

*Your favorite photographs can be enjoyed more often if you mount and frame them for display.*

also protects prints, and makes pictures stand out nicely from their surroundings.

Often it's possible to have mounting done at the processing lab where the enlargements are being made. Otherwise you can have a professional picture framer mount them, or do it yourself at much less cost. Mounting prints isn't difficult, and materials are available at art-supply stores and some camera shops.

About all you need is *mount board* and some sort of adhesive. Smooth poster board is perfect if you're also going to frame the print. If your pictures will be displayed on the mount board alone, use double-thick poster board. Or buy stronger Masonite board, which is sold at lumber yards. Some stores have mount boards precut to standard enlargement sizes. If not, or if you want to trim the enlargement to a different size, you should use a paper cutter or a straightedge ruler and a trimming knife. Don't use scissors; you can never cut a straight line with them and the mount board edges will be rough. Some art-supply and camera stores have larger paper cutters that customers can use free or for a small charge. If you're making the mount board and enlargement the same size, trim them together *after* mounting.

There are several types of *adhesives* for mounting prints, and some were mentioned in the section on photo albums. One of the easiest to use is *self-sticking mounting tissue,* like Scotch Mounting Adhesive Sheets. One side of the print tissue is first stuck to the back of the photo with even pressure from your hand or a roller, then the print is turned over and the other side is stuck in the same manner to the mount board. Protect the print face with a clean piece of paper when you're applying pressure. (An excellent bond also can be made

*Two ways to mount prints are with sheets of self-sticking mounting tissue and with photo-mounting spray glue.*

*To set your photographs off from their frames, pre-cut window mats can be purchased, or you can make your own from mount boards with an inexpensive mat cutter and straight-edge ruler.*

with *heat-sealing mounting tissue,* but a hot dry-mount press must be used. Ask at your camera store if one is available for customer use.)

Another easy way to mount enlargements is with a *photo spray glue.* Lay the print, face down, on a newspaper, then uniformly spray its back (including the edges) with the glue from the aerosol can. Align the print on the mount after the glue is tacky, cover it with a protective sheet of paper, then press into position by rubbing with your hand or a roller. Additional instructions are on the spray can. It's a good idea to practice with a small or unwanted photo first. Remember not to use rubber cement and regular paper glues, because they may penetrate the print paper and stain the enlargement.

To make a mounted print more attractive, sometimes it's covered with a *window mat,* which is another poster board with an opening that puts a wide border around the photograph and frames it. Art-supply stores frequently have precut window mats in a variety of sizes and colors; take your enlargement along to make sure it fits the opening and that the mat's color is appropriate. White, ivory, cream, and black window mats are most common, but you may want to match the dominating color in your enlargement to a mat of the same color. With practice, you can make your own window mats from poster board using a special *mat cutter* that's sold in art-supply stores.

The final step in preparing enlargements for display is *framing* them. Frames are made of wood, metal, and plastic in many sizes and shapes. They're sold in camera shops, photo studios, department stores, art shops, and other places.

Or you can buy unfinished wood molding or precut aluminum sections and make your own frames. When buying frames or do-it-yourself moldings, take the enlargement along to see how the photo will look. It could make quite a difference, for example, if the picture is framed by dark ornate wood or bright gold-finished aluminum.

Remember that glass gives extra protection to photographs. Other than ordinary window glass, you can purchase *nonglare glass*, such as Tru-Site, which makes it easier to view the picture because reflections are reduced. To keep color enlargements from sticking to the glass (or a plastic-faced frame) after a period of time, use a window mat over the picture or treat the print with a protective *photo lacquer spray*, like ProTectaCote. After you've fastened the print in its frame, use tape to seal any space between the back of the frame and the mount board so that dust and dirt won't eventually get between the glass and the face of the photograph.

Where you display a framed enlargement is a matter of personal taste. Frames with stands can be moved easily around—to a table, mantel, bookcase, desk, or bedroom vanity—until you find an attractive spot. For an enlargement that's going to be hung on the wall, have someone hold the photograph in different places so you can stand back to see how it looks. A picture on a wall is displayed best at eye level.

# 6.

# Projecting Color Slides

Although prints and enlargements can be made from color slides, they have the most impact when you project them. However, home slide shows are notoriously boring. That's because people seem to show all their pictures—good

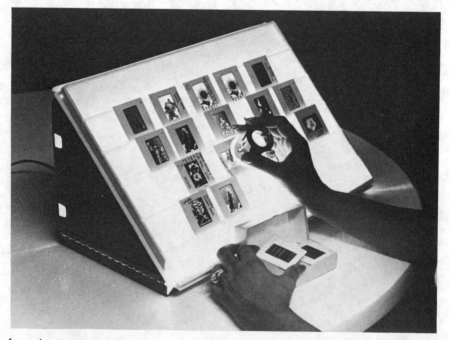

*A good way to preview and edit your color slides before projecting them is by studying the slides through a hand-held magnifier and then arranging them on an illuminated slide sorter.*

and bad—in haphazard order and keep each slide on the screen too long. And why do they introduce each image by saying "This is a picture of . . ."?

You can be different. With good editing, organization, and commentary, your slide presentations can be the talk of the neighborhood. The first thing to remember is to pick only the best of your slides to share; never show your photographic failures. Next is to keep the slides moving and make your remarks brief; after all, the pictures should be the highlight. Also, arrange the slides in an interesting sequence so your audience stays awake. And finally, keep the show short; 45 minutes to one hour of slides is long enough. That way your friends will be happy to come back another time and see more.

Start by previewing your slides with the projector or looking at them with a *slide magnifier.* Get rid of all those that are out of focus, overexposed or underexposed, or poorly composed. Then arrange the best ones by using a *slide sorter* or light box, a large illuminated viewer that lets you see a number of slides all at once.

Plan your program so it tells a story. And use variety—alternate overall views with close-ups, and vertical pictures with horizontal shots. Mix scenic shots with pictures of people. Include night photos as well as daytime exposures. Besides pictures made out of doors, show interior shots. Arrange the slides so your story has a beginning, middle, and end. Humorous pictures or comments will help keep the attention of your audience, too.

Besides content, you should consider the equipment you're using for a slide show. A good projector and screen are necessary if you want the program to run smoothly and the pictures to be seen at their best. (If slides are dusty, clean them with a camel's-hair brush that's sold at camera stores.)

There are basically three sizes of *projectors* to handle the different sizes of slide film. Most common are 35mm projectors accepting 2×2-inch slide mounts, which hold 35mm and 126-size Instamatic-type transparencies. The smaller 110-size pocket camera slides usually are returned from the processor

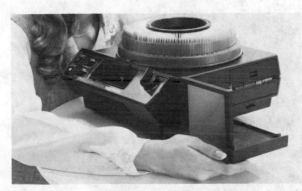

*Some models of Kodak's popular 35mm Carousel slide projectors feature a small built-in viewing screen. All Carousel projectors use circular trays that hold from 80 to 140 slides.*

in 30mm-square mounts, and these work best in the pocket slide projectors. However, slides from 110 film also can be placed in special 2×2-inch adapters or remounted in 2×2-inch mounts for use in 35mm slide projectors. A larger projector is needed to show the 2¼×2¼-inch transparencies of 120-size film.

Regardless of the projector required for the size of your film, it should produce sharp and bright images, and there should be little chance of damage to your slides. The most popular 35mm and pocket slide projectors are Kodak's Carousel models. Of great significance is their gravity-feed design, which does not require force to put a slide into position for viewing.

Another plus for Carousel projectors is their quiet operation. The slide-changing mechanism and cooling fan in some projectors make lots of noise and will distract the audience. Carousel projectors also feature remote-control

*Projection screens should be square so you can show vertical as well as horizontal images.*

focusing or auto-focusing to keep each slide image sharp, and a remote control to advance or reverse the slides when you're sitting away from the projector.

It's helpful if you don't have to change a lot of slide trays during a show. The Carousels have easy on-and-off circular trays that hold 80 or 140 35mm and 126-size slides, or 120 pocket camera slides. One warning: The 140-slide tray accepts only cardboard-mounted slides, and any slides that are slightly bent or have damaged corners will not drop into the projector for viewing. So it's better to use the 80-slide trays when giving a show with 35mm or 126-size slides.

To be seen right side up, slides must go into the projector upside down with the dull (emulsion) side facing the screen. After you've arranged them in this manner and before putting them in the tray, mark the upper right-hand corner and top of the slide mount with a felt-tipped pen. Then whenever you pick up the slides, you'll know without even looking at their images what direction to put them in the tray for correct projection.

Also consider the *projection screen* you're going to use. Bedsheets or living-room walls aren't the best surfaces to show your slides on, because the images won't be smooth or very bright. The best screen for home viewing is a lenticular type. It comes in a roll on an attached stand and must be stretched taut for uniform viewing results. This screen usually has a slightly gray and ribbed plastic surface, which reflects a bright image. For home viewing, a 4-foot-square screen is a good choice. You'll want a square screen not only for square-format slides but for rectangular 35mm or pocket slides too, because you'll want to project some vertically and others horizontally.

When you invite people to see your slide show, be ready. Have the projector and screen in place. Be sure the table or stand for your projector is sturdy so the images won't shake on the screen. Clean the projector lens so the slides will look sharp and bright.

Make sure that everyone will have a good view of the screen, and that the room can be completely darkened (stray light falling on the screen will reduce the color and brightness of your slides). The first slide should be in place and prefocused. Always have a spare projection bulb on hand in case one burns out in the middle of your program. Also be sure you know how to retrieve a slide that might become jammed in the projector.

If you're prepared, and give a brief and well-organized show of only your best slides, your family and friends will think you are quite a photographer. And when they say they want to see more of your pictures, they'll really mean it.

# 7.

# Making Photo Greeting Cards

You'll have fun showing off your pictures by sending photo greeting cards. Christmas is the most popular time to use pictures for personal greetings, but they are also ideal for birth announcements, thank-you cards for wedding gifts, and other uses.

The Eugene J. Voss Family Wishes You An Old-Fashioned Merry Christmas

*Some processors offer overlay printing services so your name or a brief message will appear on your photo greeting card.*

Friends enjoy seeing the newborn infant and proud parents, or receiving a keepsake shot of the happy bride and groom. And most people appreciate receiving a photo anytime, whether it's for a special occasion or not. Photo cards can be made in a variety of ways.

One idea is to have a number of duplicate prints made from a negative, slide, or instant print, glue them to blank greeting cards bought in a stationery store, and write a personal message before you mail them.

Another method is to have a short message printed directly on the print and send it as it is. Kodak offers an *overlay printing* service; one or two lines with your message and/or name will appear in white in the image area near the bottom of the color prints. These can be ordered through your camera store.

Kodak also offers greeting cards featuring preprinted Christmas, birth-announcement, and thank-you messages with a color photo. Envelopes are included.

*To make your own photo greeting cards, like this birth announcement, arrange a photo and message on a full-size piece of paper, have photocopies made, and then fold the copies in quarters to fit in an envelope (see text).*

You also can create eye-catching *photocopied greeting cards* that reproduce a black-and-white or color picture together with your personal greeting. Start with a piece of clean white standard 8½×11-inch paper, and fold it in fourths. Fold the long way first if you want a horizontal card, or in the short way first if you want a vertical card. Mount the picture on the front side, then open the

*Prints can be sent to friends as photo postcards by inserting them in cardboard frames made by Kodak, or by gluing them to the front of a regular postcard.*

page and write your message on the inside (or type it there before you mount the picture). Unfold the card until it's flat again, and have high-quality photocopies made. (Use a machine that copies photographs well.) Afterward, fold each copy into a card as you did the original, and slip them into envelopes for mailing.

Pictures with your greetings also can be sent as *photo postcards*. Kodak makes a postcard frame in which you can insert a PR-10 instant print or other picture that has a 2½×3½-inch image area. Or glue a photo to the front of a regular postcard and trim the picture to size. Also, if you have your own darkroom, there are special postcard photo papers you can expose with a negative by contact printing or enlarging to make black-and-white images. These are Kodak's Azo and Kodabrome postcard papers.

By the way, you can get color *photo business cards* made from one of your color negatives or slides. Printed information (name, address, phone number, etc.) is included. Kodak offers this service through camera stores.

One unusual way to display your pictures is by making a *photo T-shirt*. A color image from a print or slide can be enlarged and transferred to cloth by a color Xerox process. You can have this done at some photocopy centers or by order through some camera stores.

Slides produce the best images. Choose one that has rich colors and sharp detail. It will be enlarged to about 8×14 inches onto heat-activated transfer copy paper. This is placed on the T-shirt or other cloth and put in a hot press to transfer the color image. (Some photocopy shops offer this transfer service, or go to a T-shirt store.) There's nothing like showing off one of your photographs by wearing it around!

Some of your pictures shouldn't be seen—except by an insurance adjustor.

*Most pictures are taken for your own enjoyment, but a practical use for your camera is to make a photographic inventory of antiques and other valuable possessions in your home.*

These are color photos you take for a *photographic inventory* of your home and valuables in case of fire, theft or other disaster. Keep these prints in a bank safety deposit box until you need proof of your loss. When shooting such an inventory, take overall views of your home, yard, car, boat, etc. as well as close-

up pictures of all your valuables. And don't forget to update the inventory occasionally by photographing new possessions.

While doing a photographic inventory is a serious use for photography, most of your pictures will be taken for fun—and that's the way it should be. Just remember to make your camera a constant companion so you won't miss any photo opportunities. By following some of the suggestions in this book, you're bound to take better pictures—and get more enjoyment out of photography. Happy shooting!

# Index

(Page numbers set in boldface refer to illustrations)